# Along the Divide

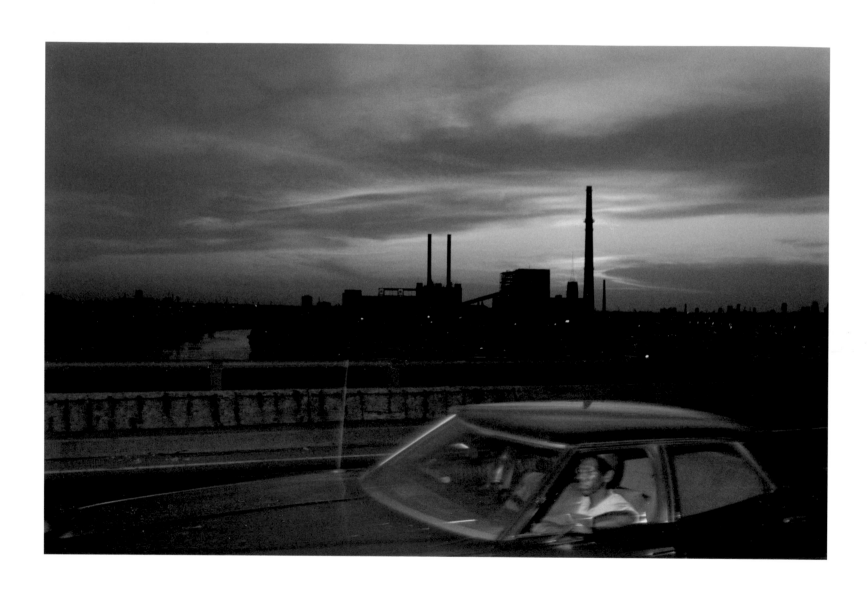

# Along the Divide

### Photographs of the Dan Ryan Expressway

## Jay Wolke

### with a conclusion by Dominic A. Pacyga

The Center for American Places
Santa Fe, New Mexico, and Staunton, Virginia

in association with

COLLEGE CHICAGO

## Publisher's Notes

*Along the Divide: Photographs of the Dan Ryan Expressway* is the fifth volume in the series *Center Books on Chicago and Environs*, created and directed by the Center for American Places, with the generous financial assistance of the Graham Foundation for Advanced Studies in the Fine Arts. The book was issued in an edition of 2,200 hardcover copies, and was brought to publication with the generous support of Columbia College Chicago and Jeanne and Richard S. Press, Nancy and Ralph Segal, and Jack Jaffe, for which the publisher is most grateful. For more information about the Center for American Places and the publication of *Along the Divide: Photographs of the Dan Ryan Expressway*, please see page 88.

Copyright © 2004 Center for American Places
Photographs copyright © 2004 Jay Wolke
All rights reserved.
Published 2004.  First edition.
Printed in Iceland on acid-free paper.

Center for American Places, Inc.
P.O. Box 23225
Santa Fe, New Mexico 87502, U.S.A.
www.americanplaces.org

Distributed by the University of Chicago Press
www.press.uchicago.edu

9 8 7 6 5 4 3 2 1

Library of Congress Cataloging-in-Publication Data is available from the publisher upon request.

ISBN 1-930066-28-7

# Contents

# Along the Divide
### Photographing the Dan Ryan Expressway

**Jay Wolke**

One of the nation's most heavily traveled and notoriously dangerous expressways, the Dan Ryan cuts a giant swath through Chicago's densely populated South Side neighborhoods. A fascinating urban ecosystem has developed around the road, an interwoven structure of human and industrial elements. Between 1981 and 1985 I produced thousands of images and traveled thousands of miles while grappling with the representational challenges inherent in this subject. It was an extremely formative body of work and became as much a vehicle for me as an artist as it has been a conduit for the millions of others who use it every year.

I wanted to examine the road as a massive expression of the urban lexicon. The considerable extent of the Dan Ryan's influence over its surroundings, as well as the proliferation of adaptations to its unremitting presence, offered me an invaluable opportunity for photographic interpretation and construction. The enormity of its engineering continuously plays the geographical off the human. As elements proceed through time and space, scale is measured both physically and historically. The experience of driving this expressway may range from total functionality to devastating *dis*-functionality. Still, the great subtext underlying all circumstance here is the politics that created the Dan Ryan. Those politics determined who would benefit or suffer from its construction. I have often referred to the Dan Ryan as a linear buffer that acts as a cushion for those people who want not only a link to the city, but also a definable separation from the "realities" of city life.

Ultimately, though, my photographs are about the nature of representing such an enormous edifice; I consciously shifted format and attitude to reflect better the diversity of the environment and my understanding of it. A great challenge was to pre-visualize, often months or even years in advance, how and when I could best represent my ideas about this arterial organism. I had to become sympathetic with the Dan Ryan's cycles and flows, its causes and effects. Many different activities and populations are involved with it at different times, and my approach often depended not only on the good will and cooperation of private individuals and public institutions, but also on the climate and environment.

This was a wonderful project for me. It taught me an enormous amount about the world and it demanded a level of professional rigor that I continue to incorporate into my working method. It was also a great pleasure to review these images once again, and to edit a new body of work from an older one. Twenty years of distance granted me a less biased view of these photographs, which helped me to create a narrative that reflects the enduring dynamic of the Dan Ryan Expressway, and the intended strength that I'd hoped for when the project began. Many of my subjects, both human and architectural, have since changed, moved, or disappeared, but the Dan Ryan remains as a monolith of urban engineering, and continues to affect the culture and commerce of Chicago and the nation.

**Along the Divide**

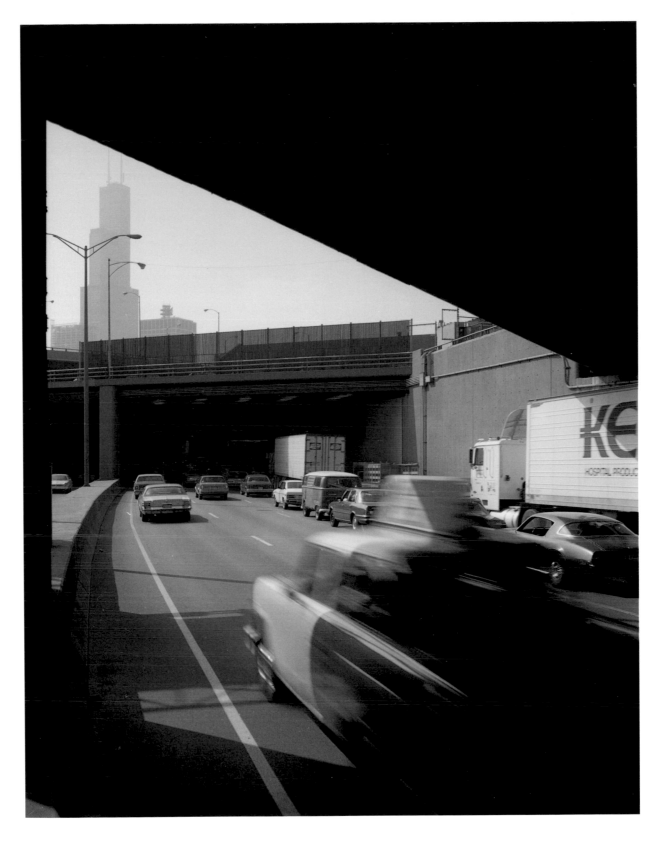

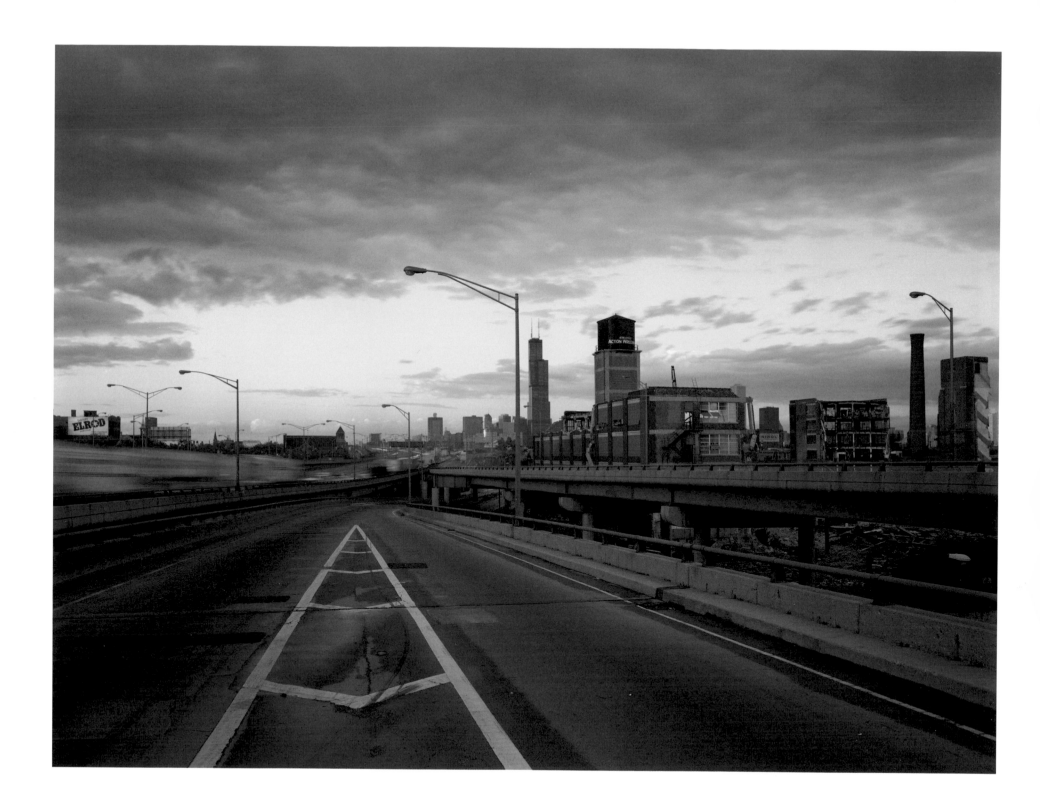

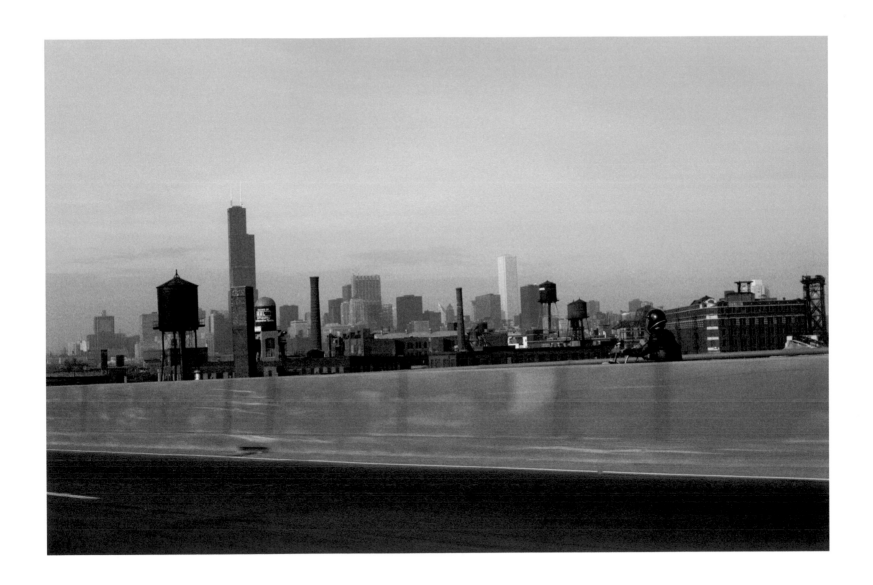

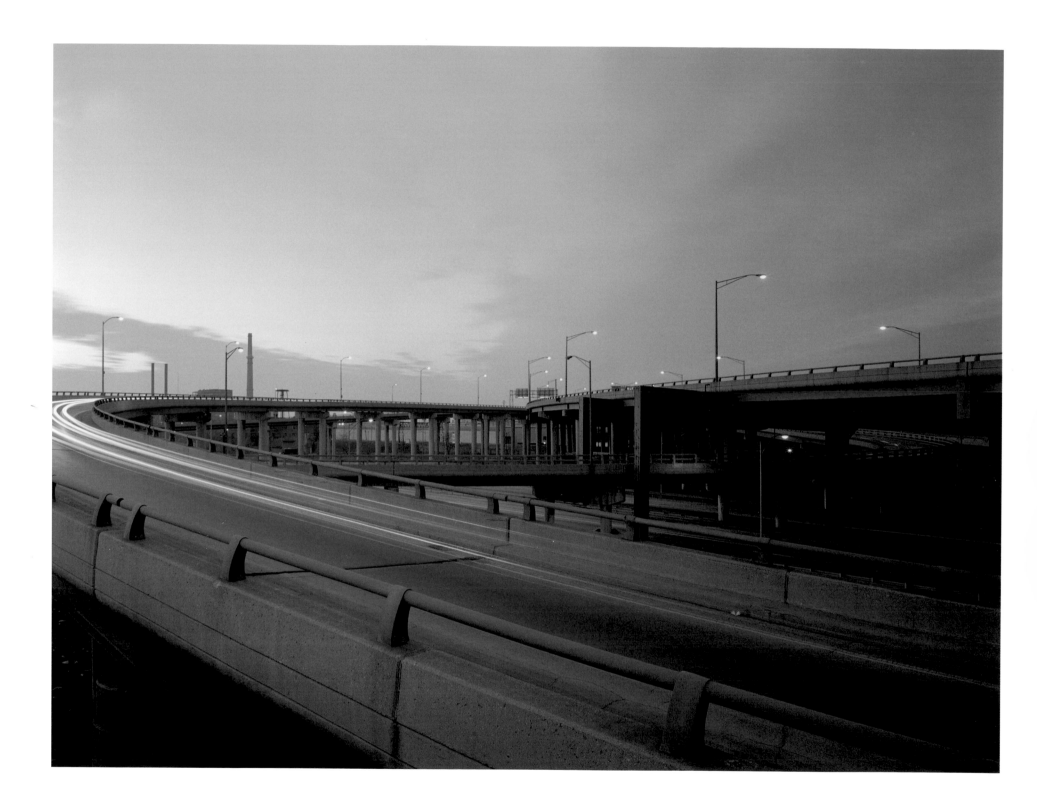

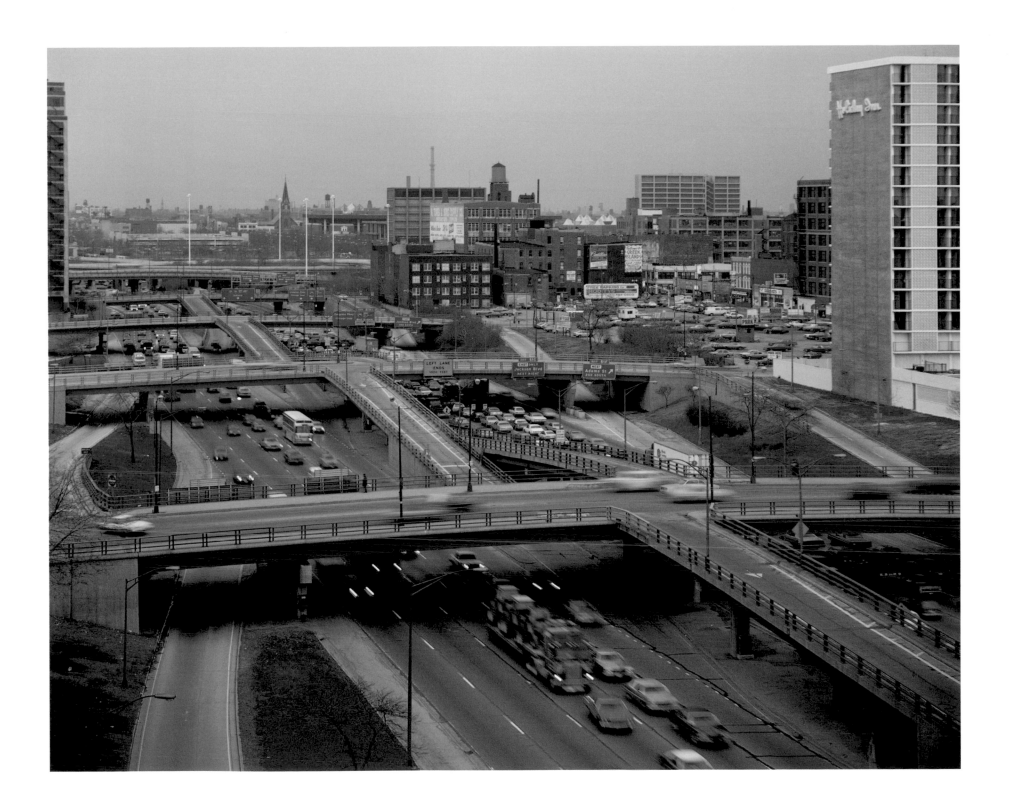

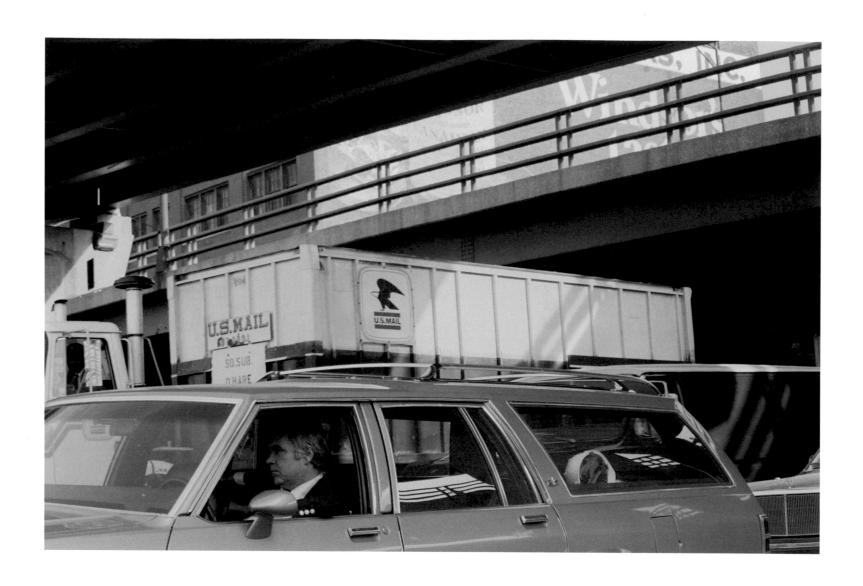

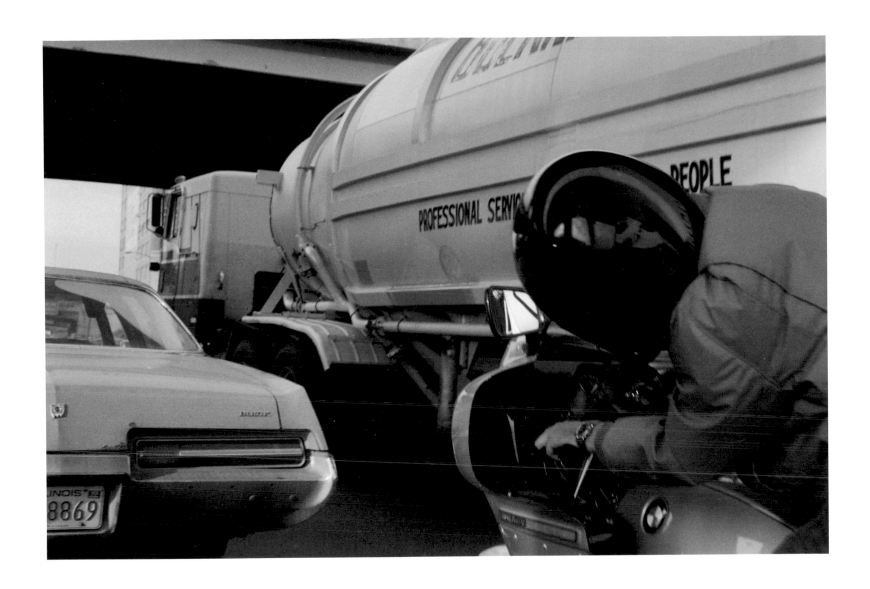

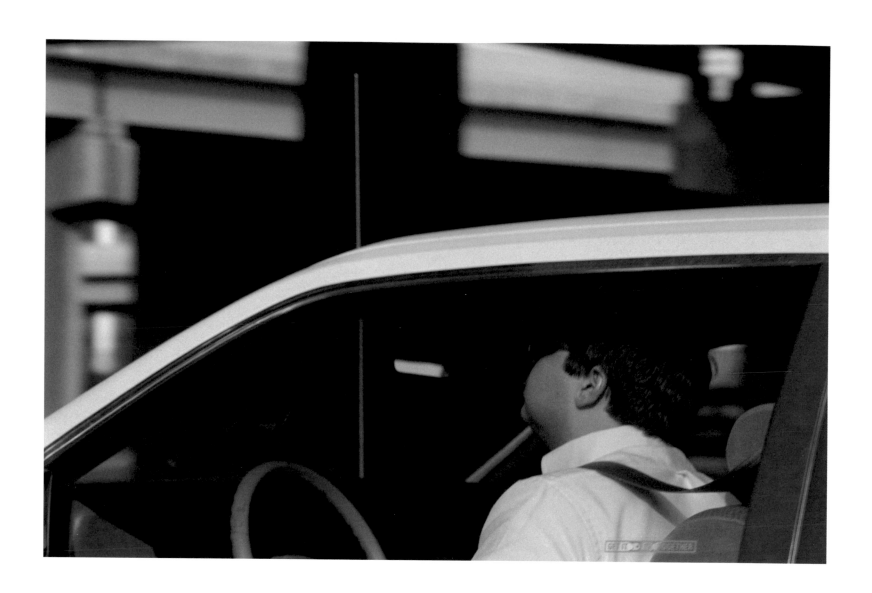

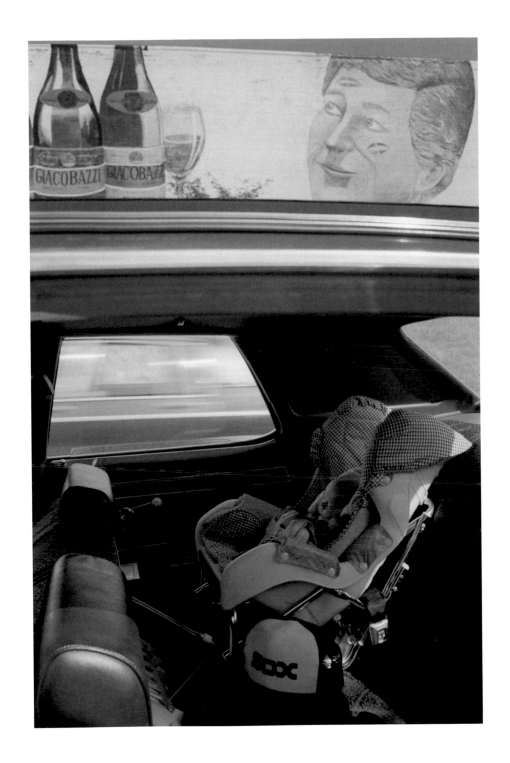

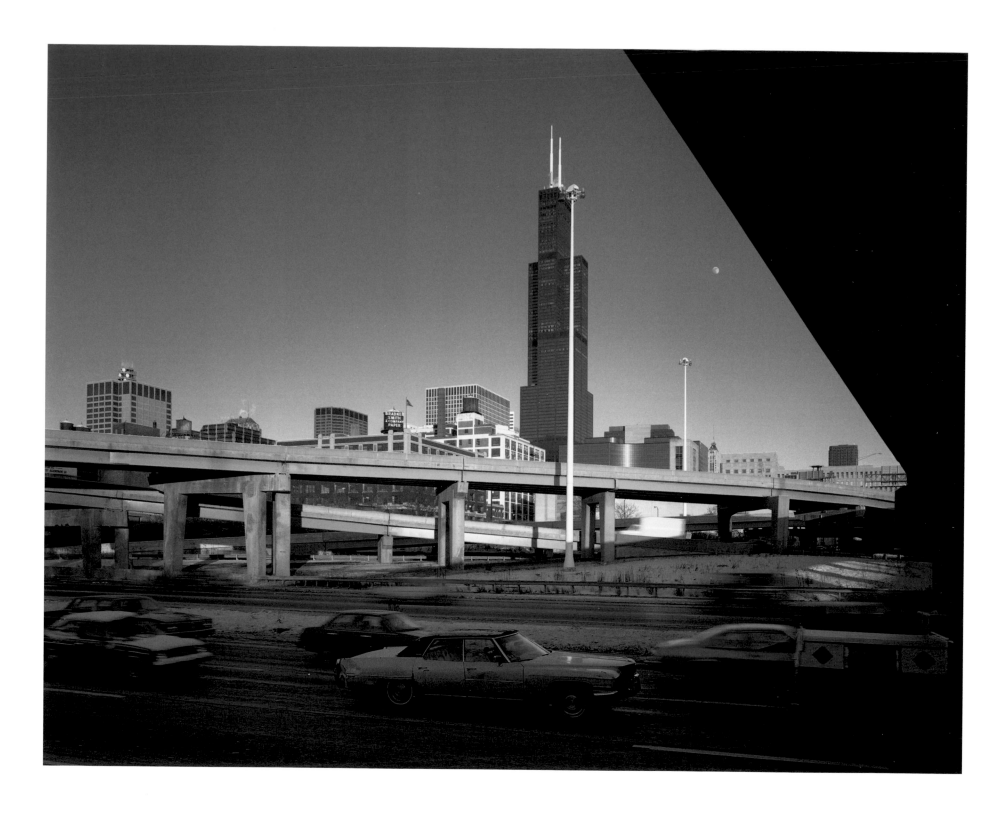

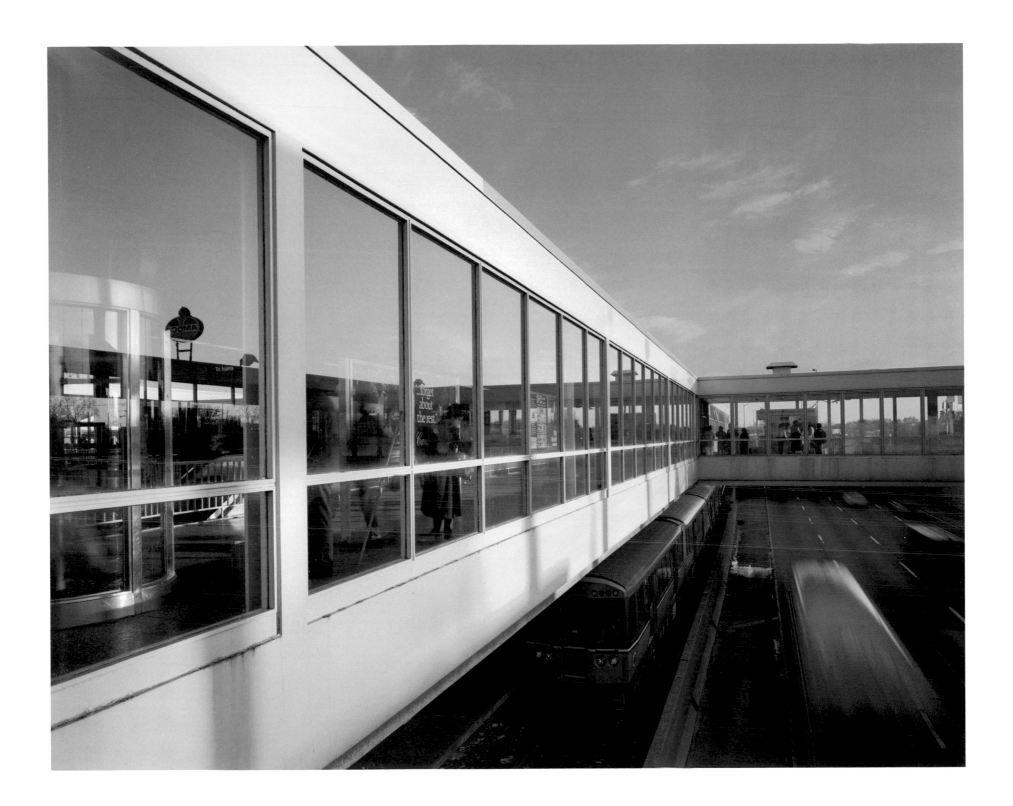

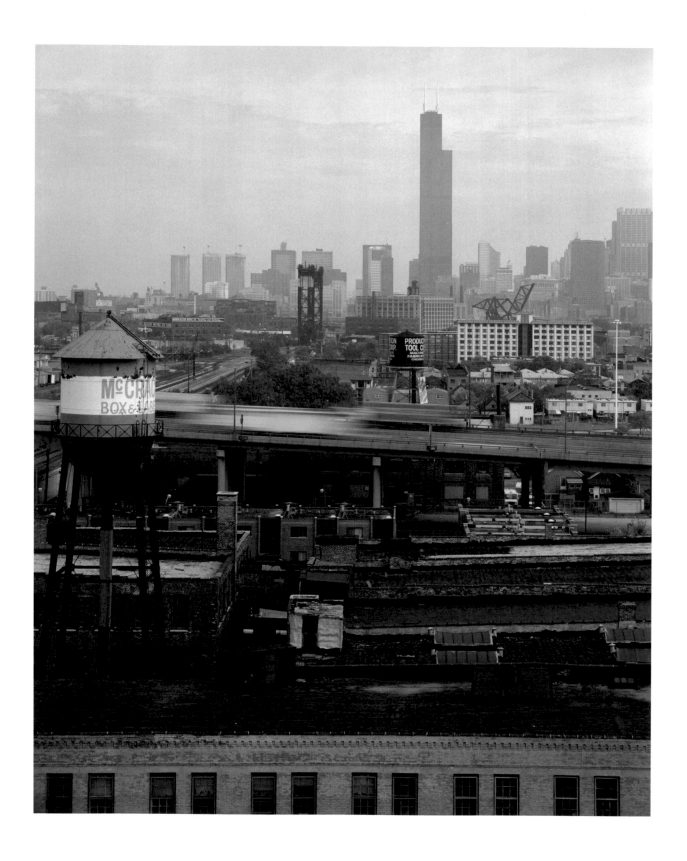

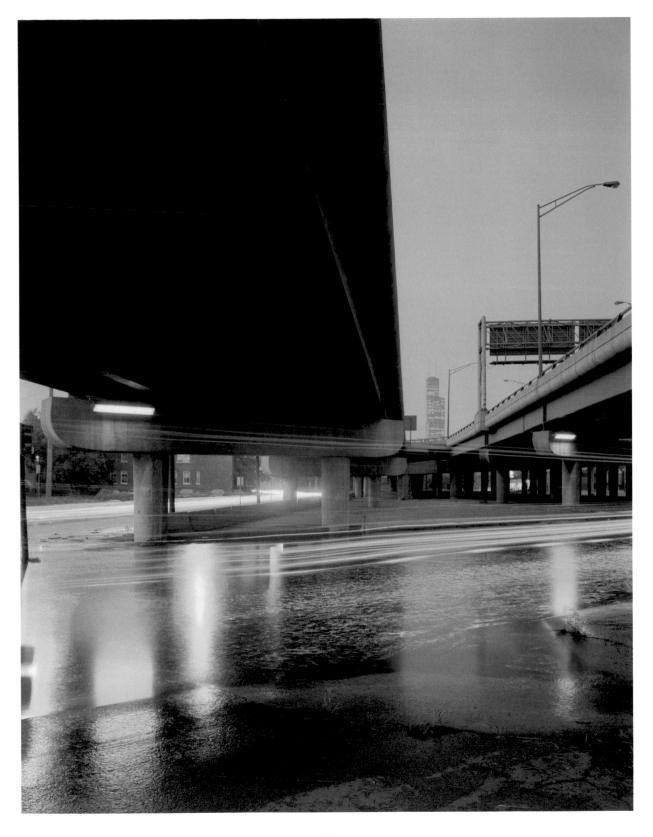

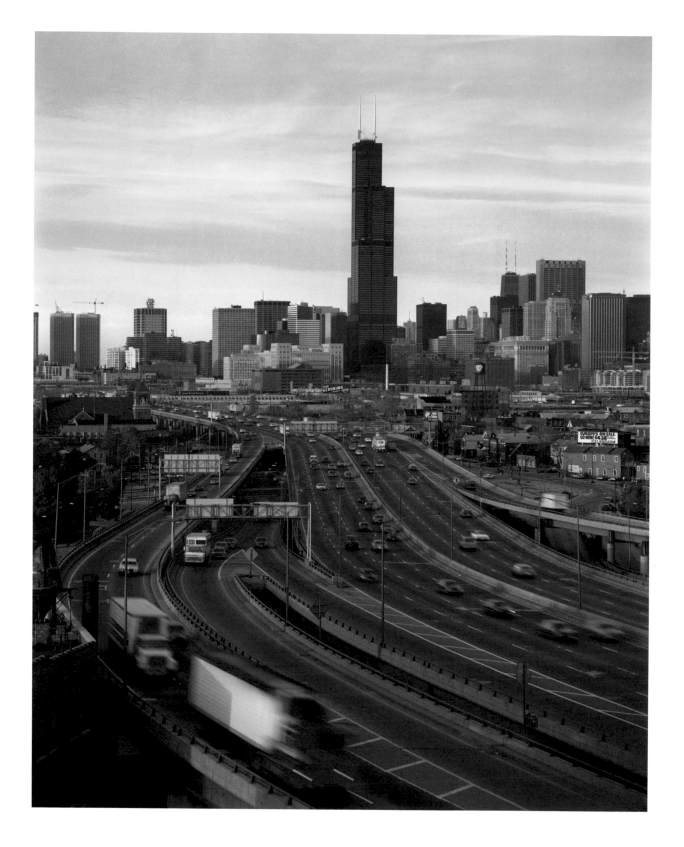

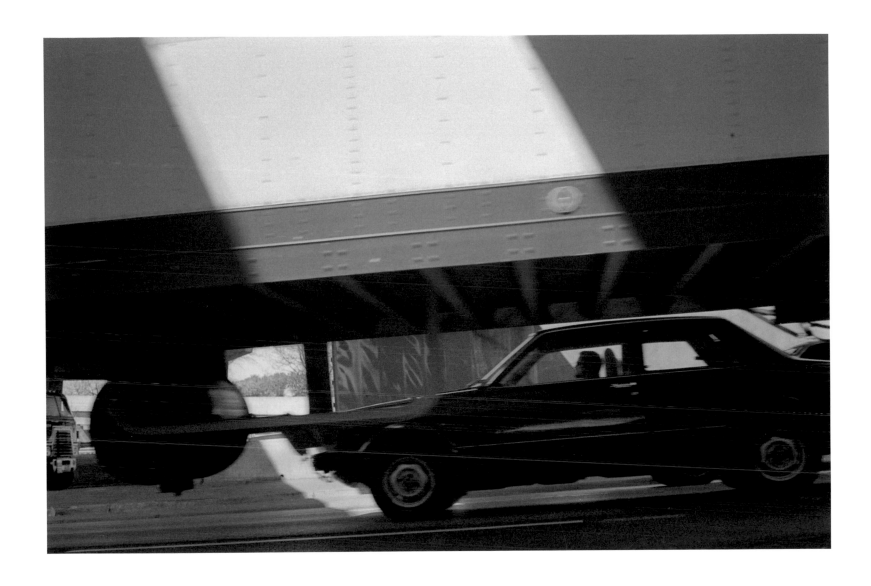

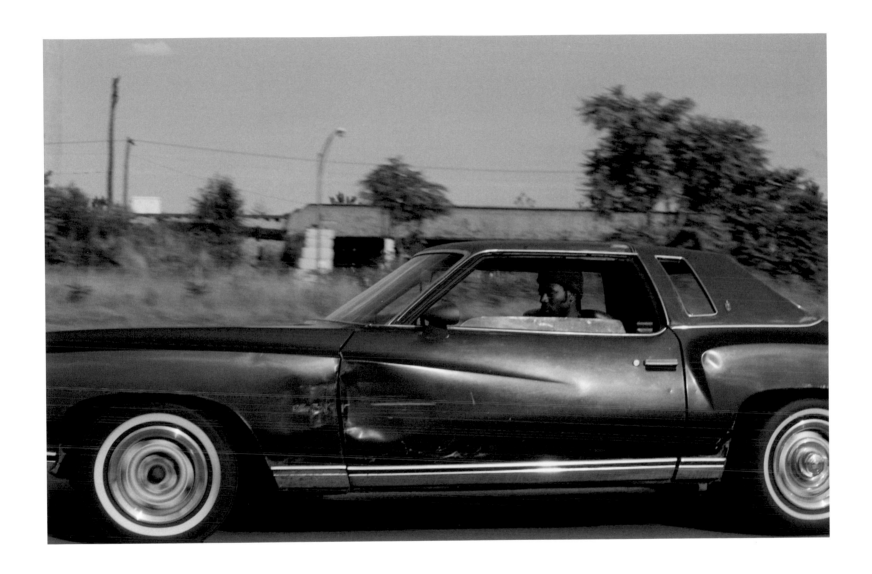

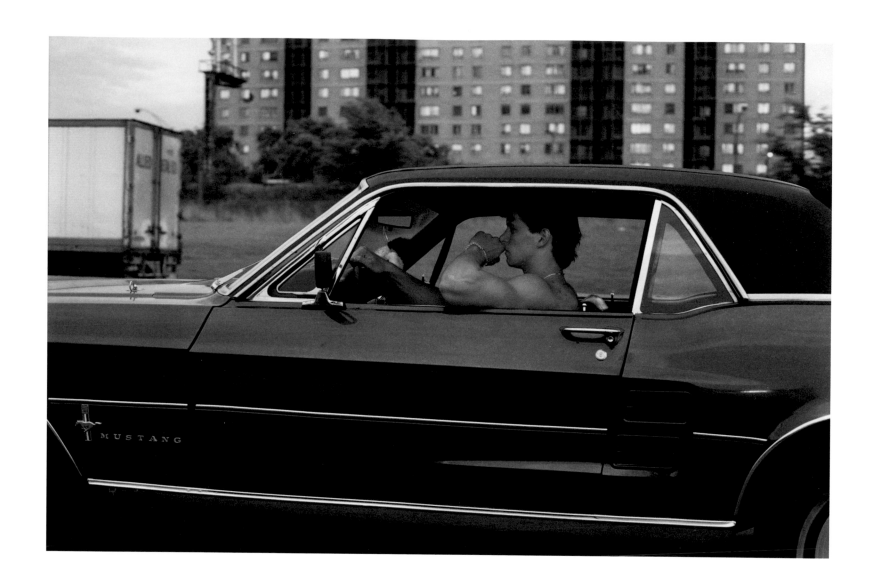

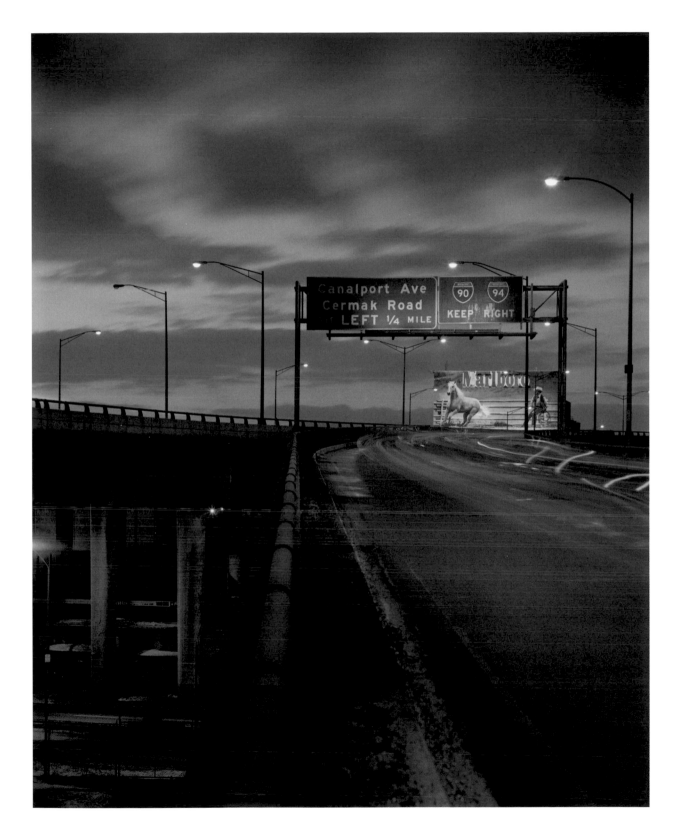

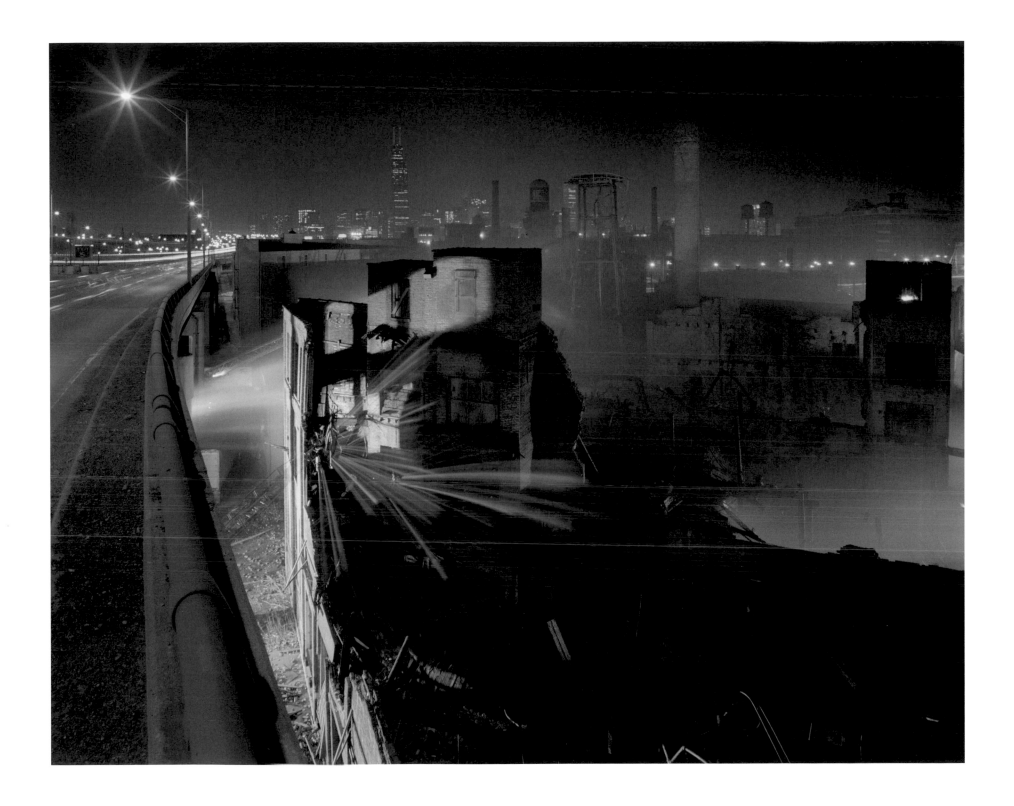

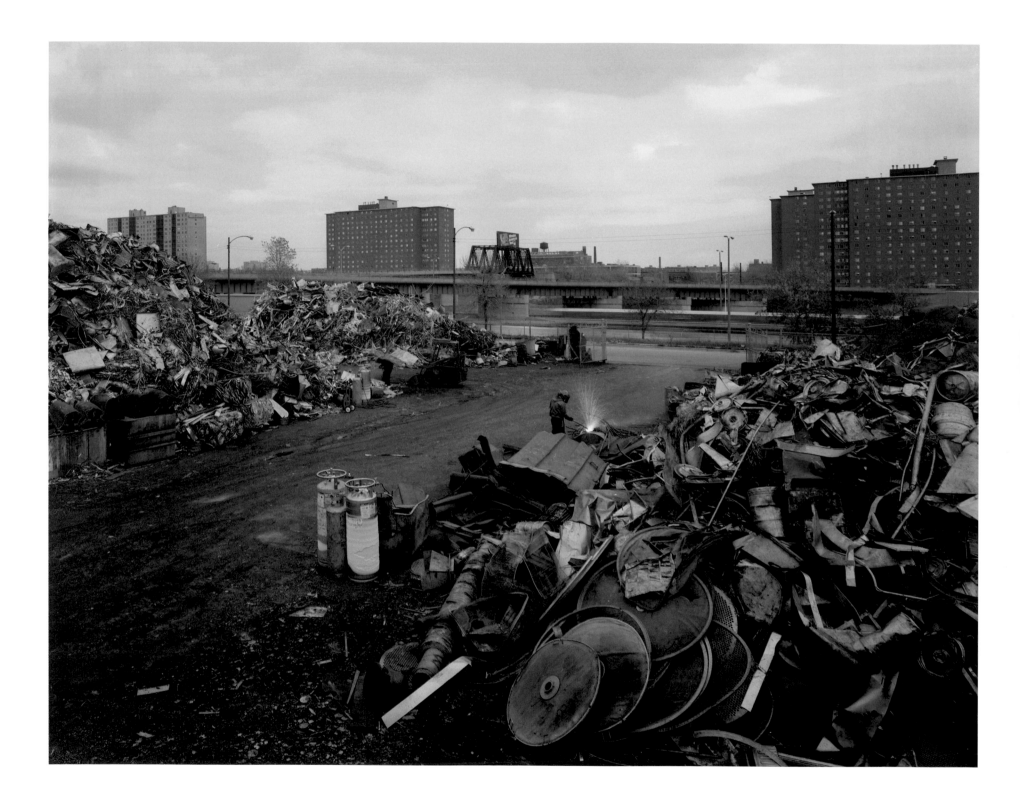

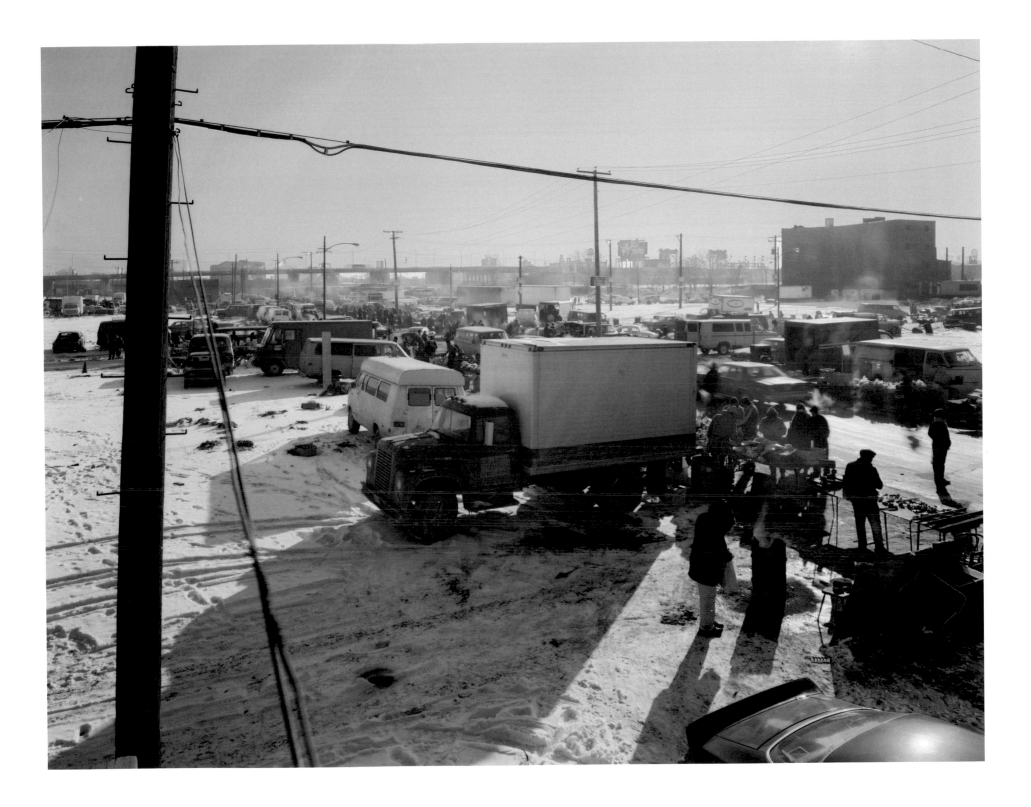

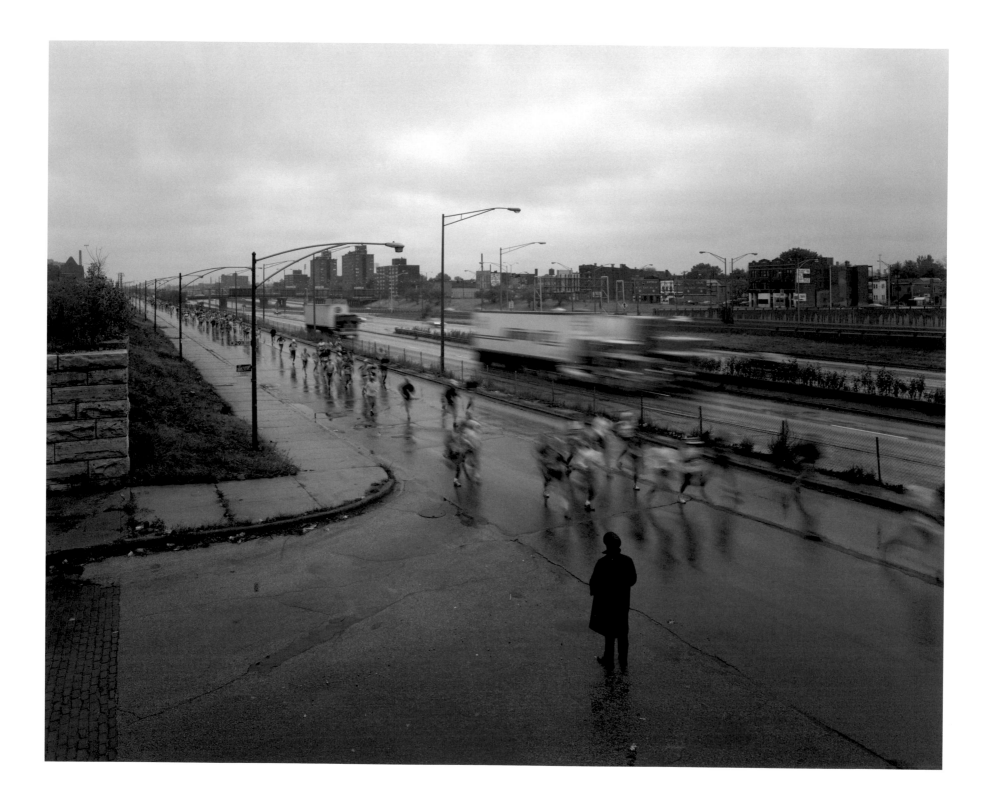

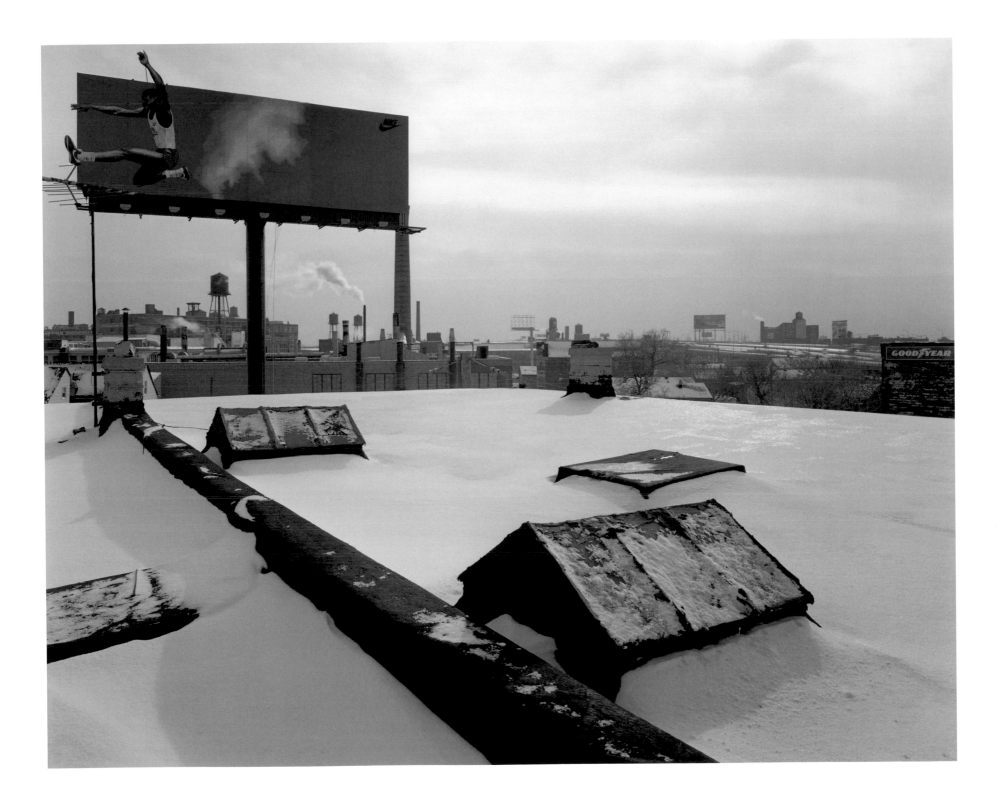

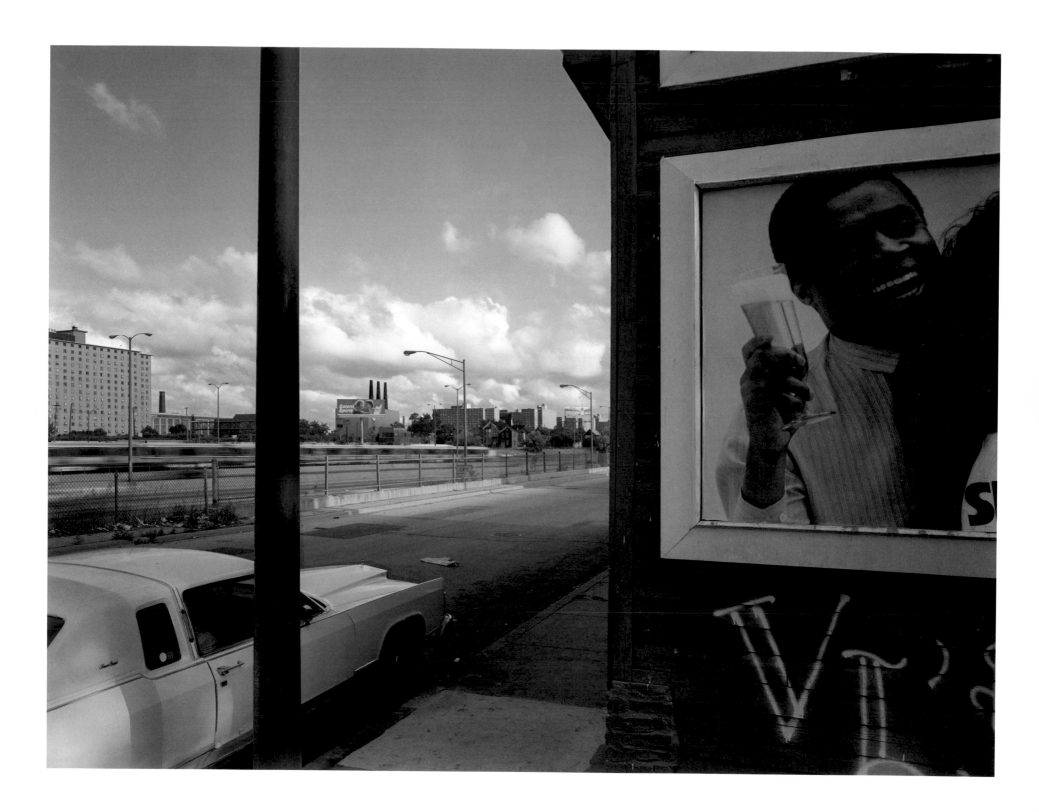

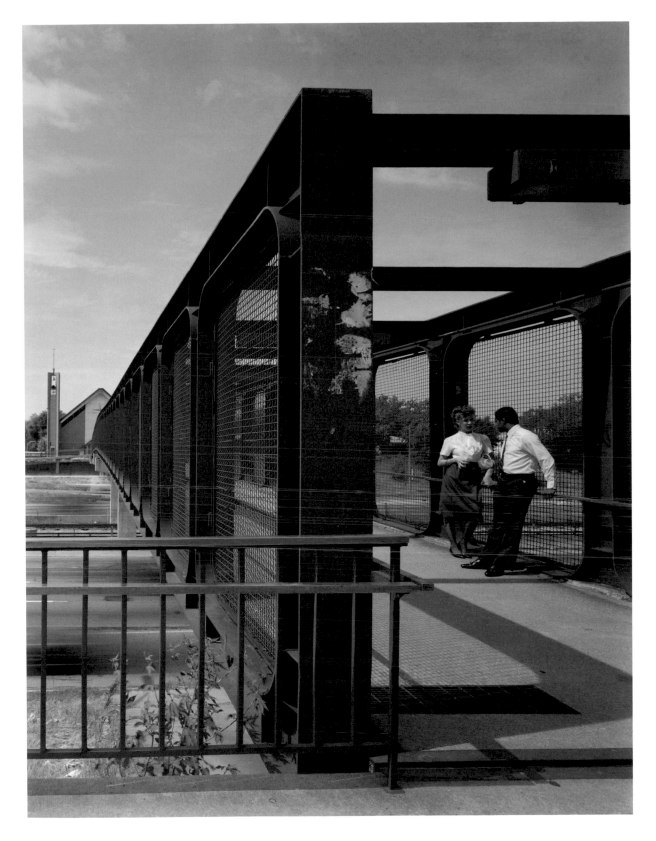

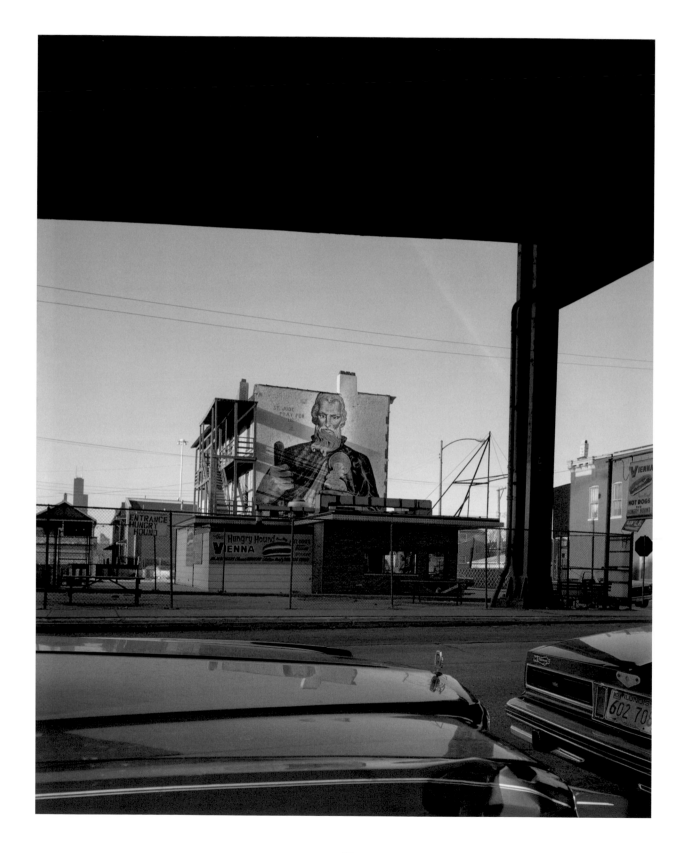

30

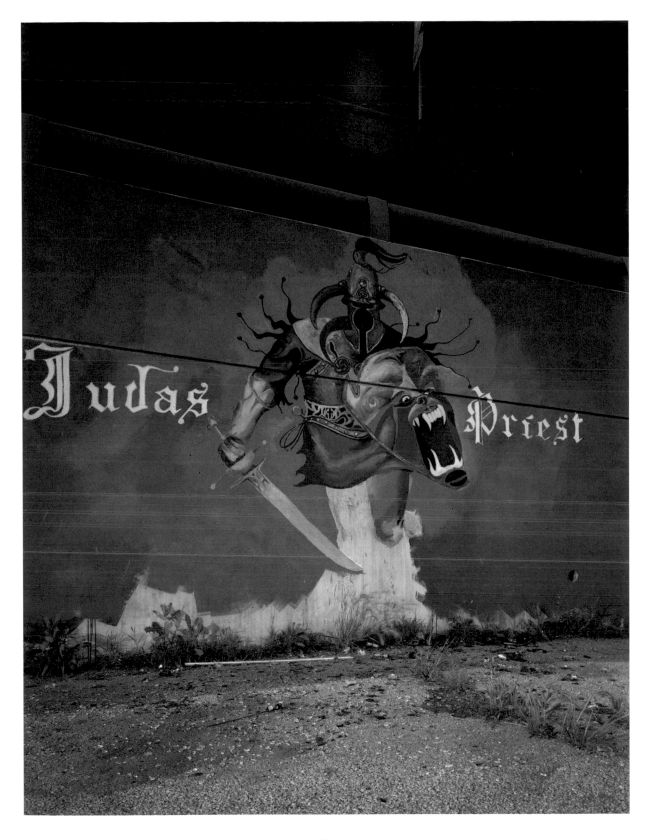

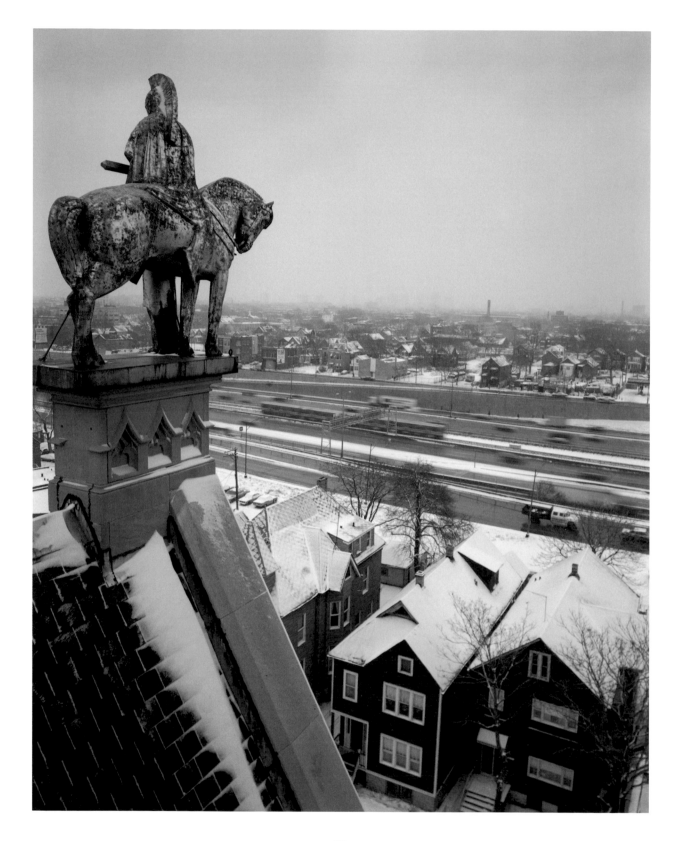

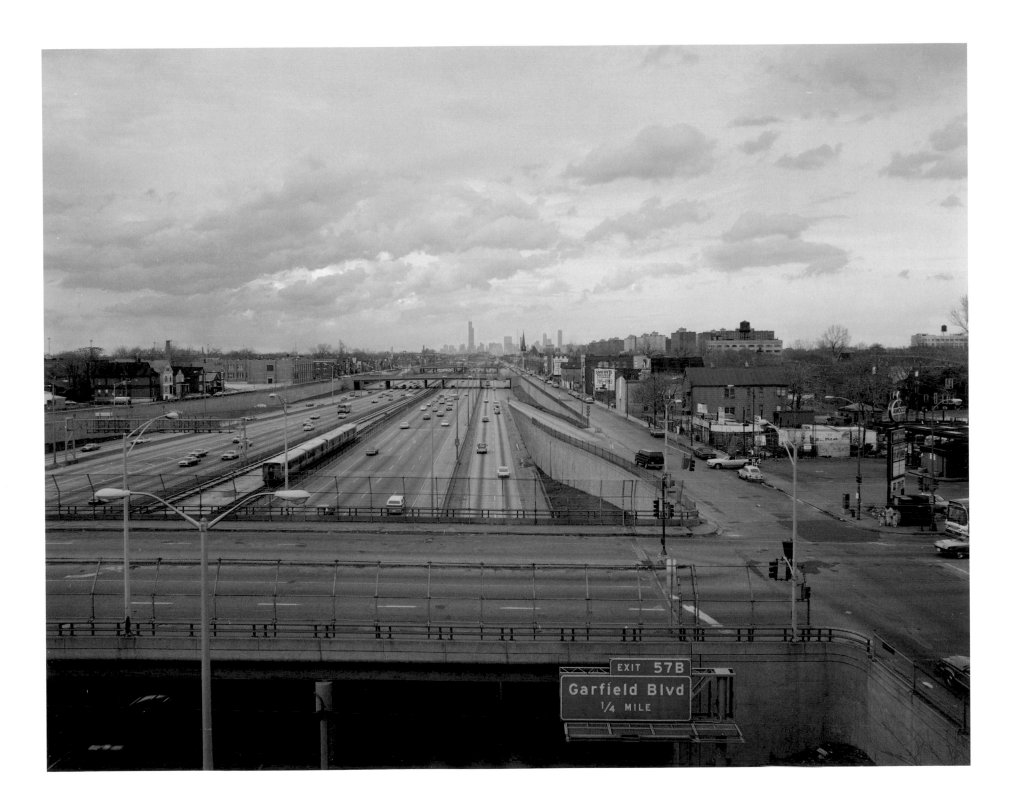

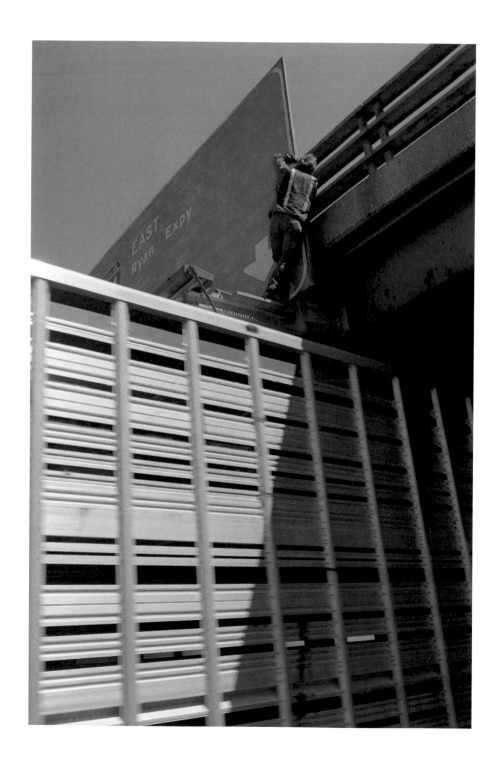

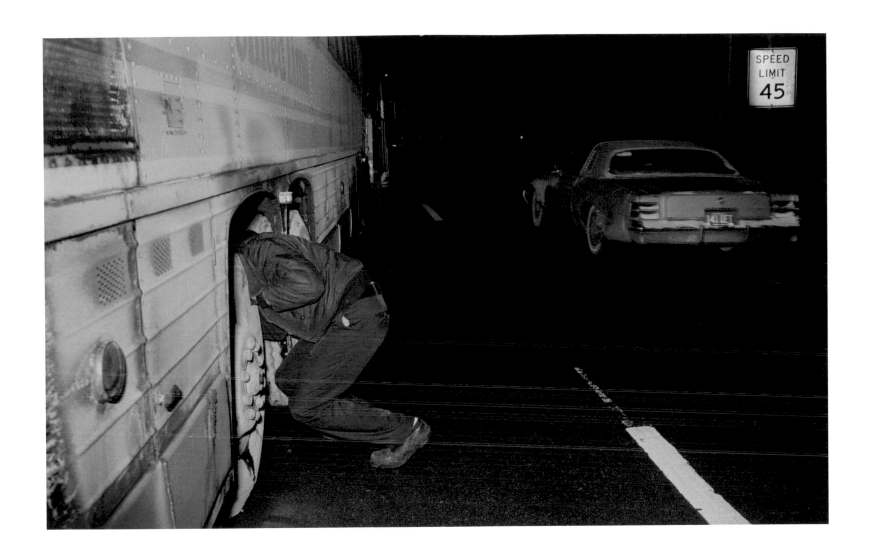

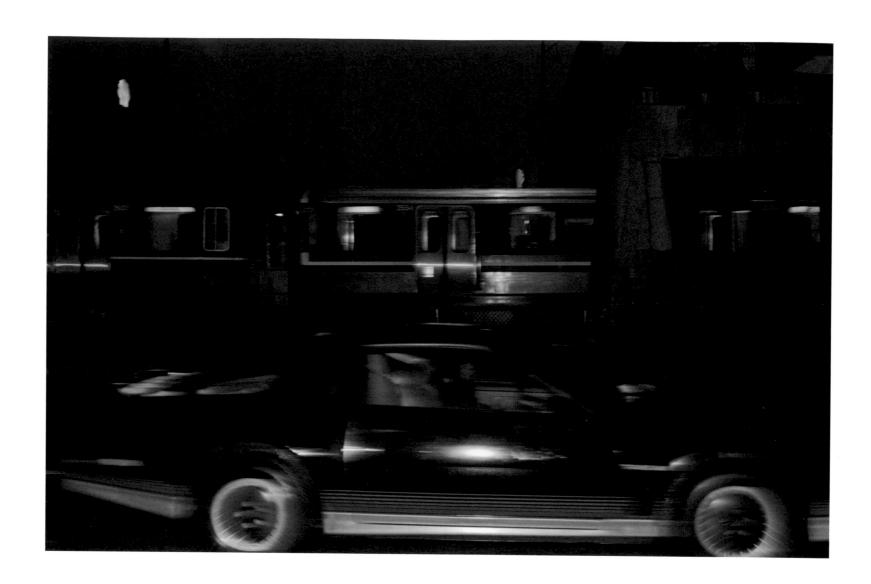

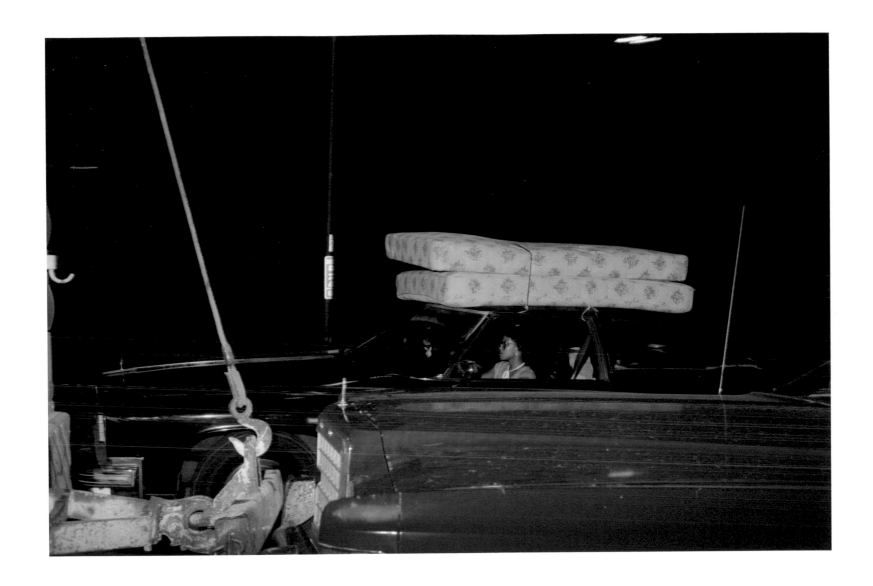

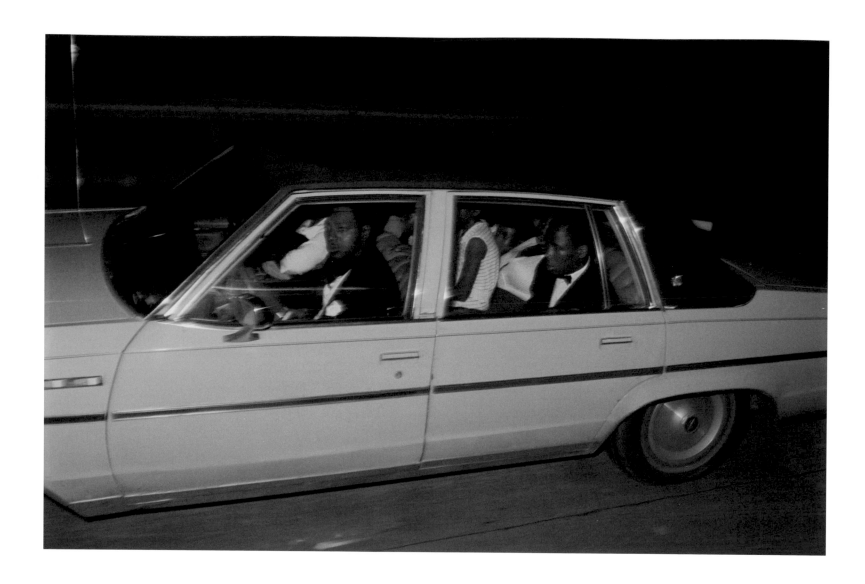

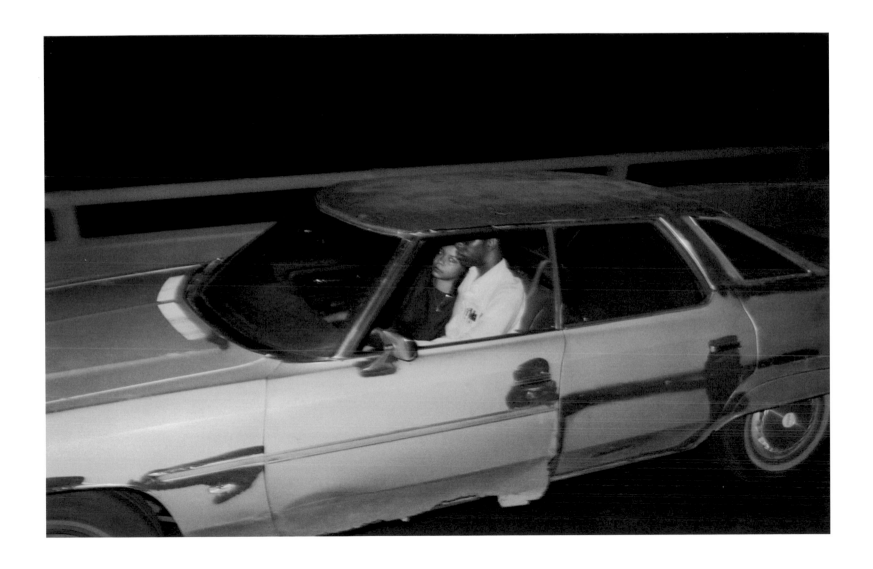

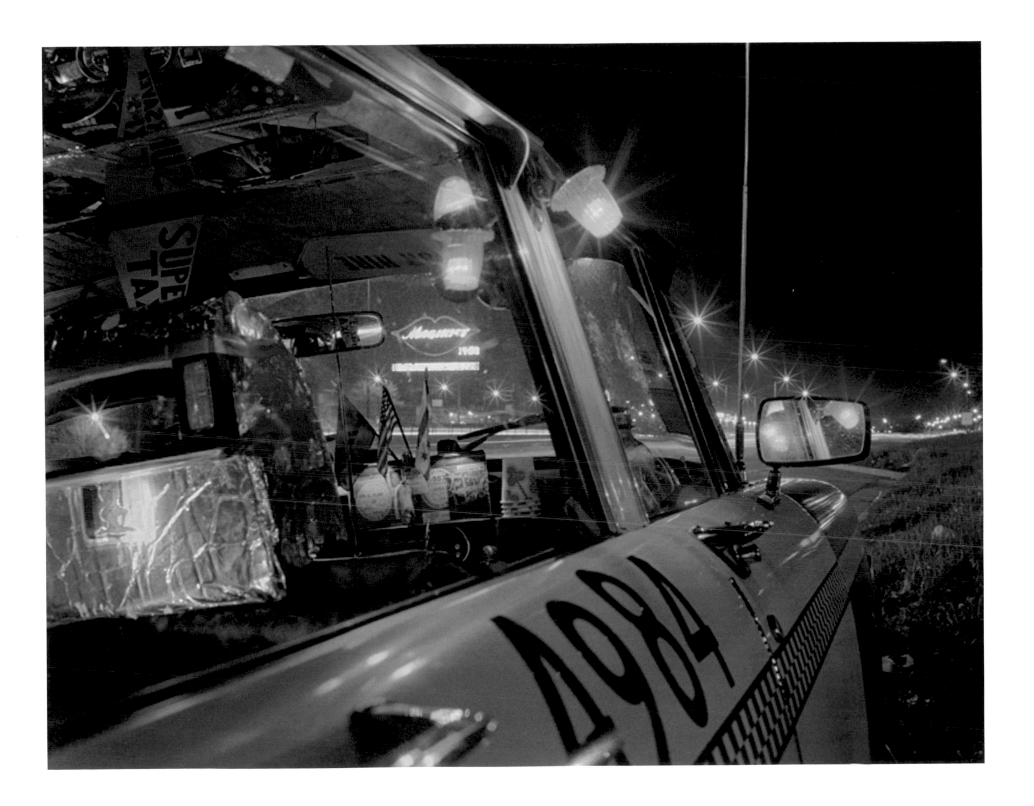

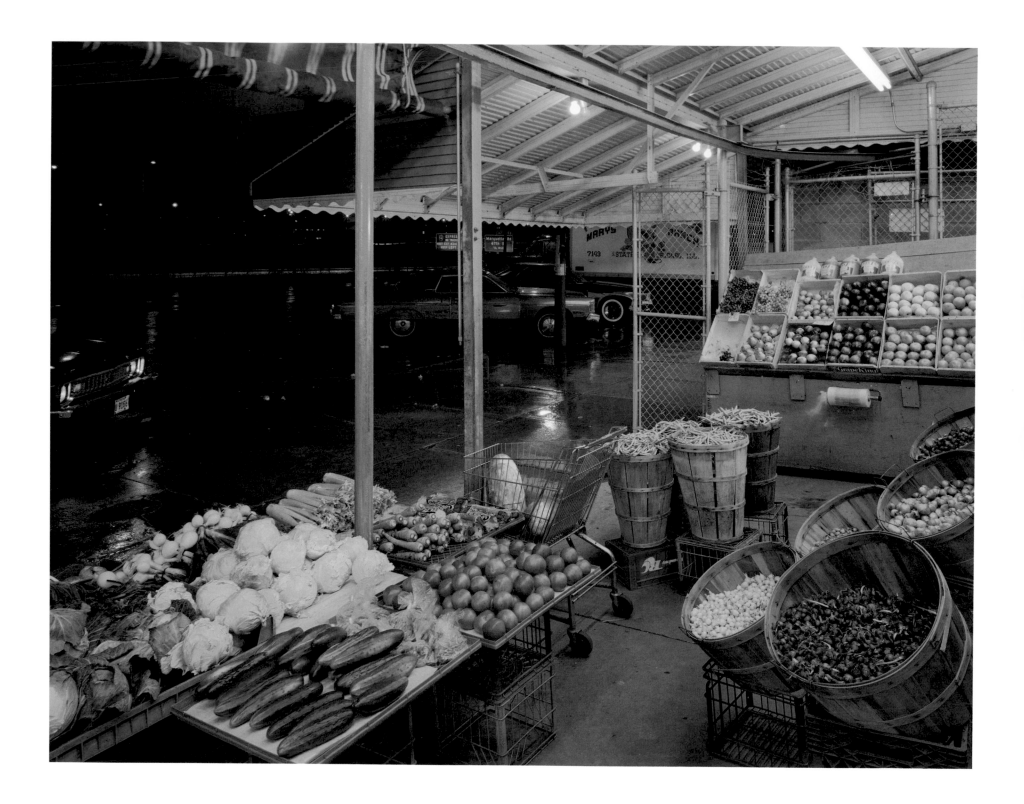

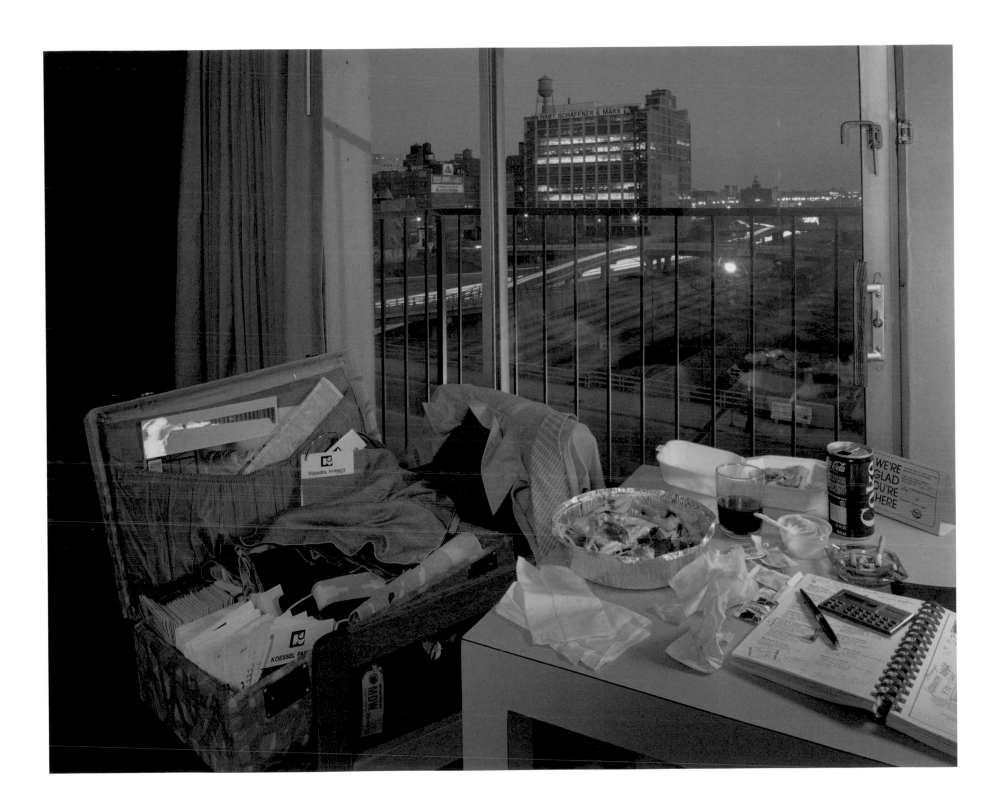

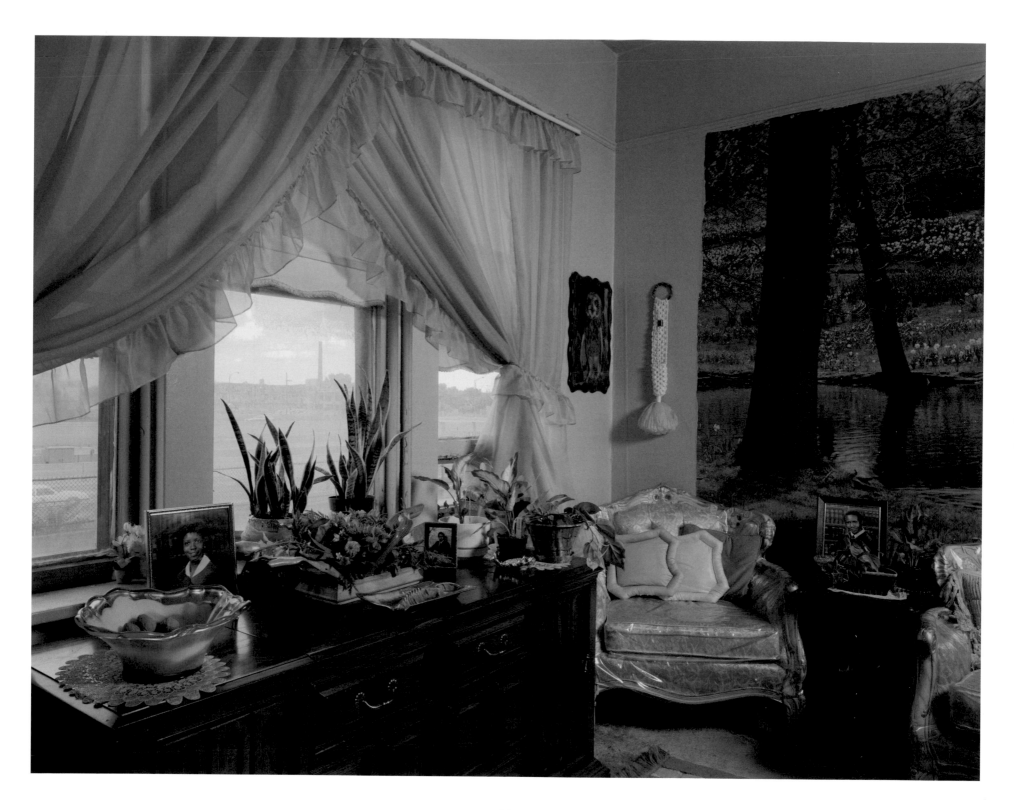

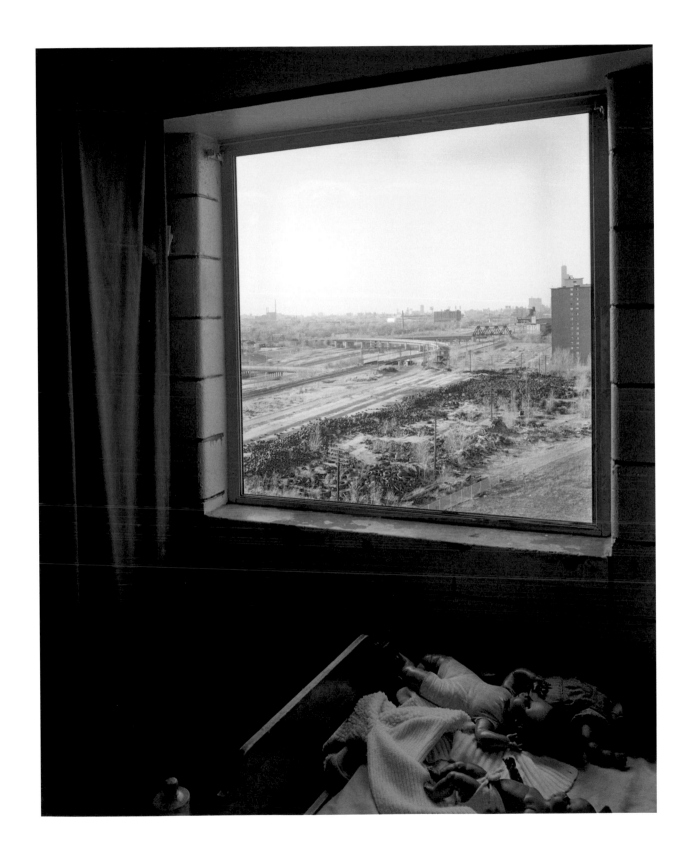

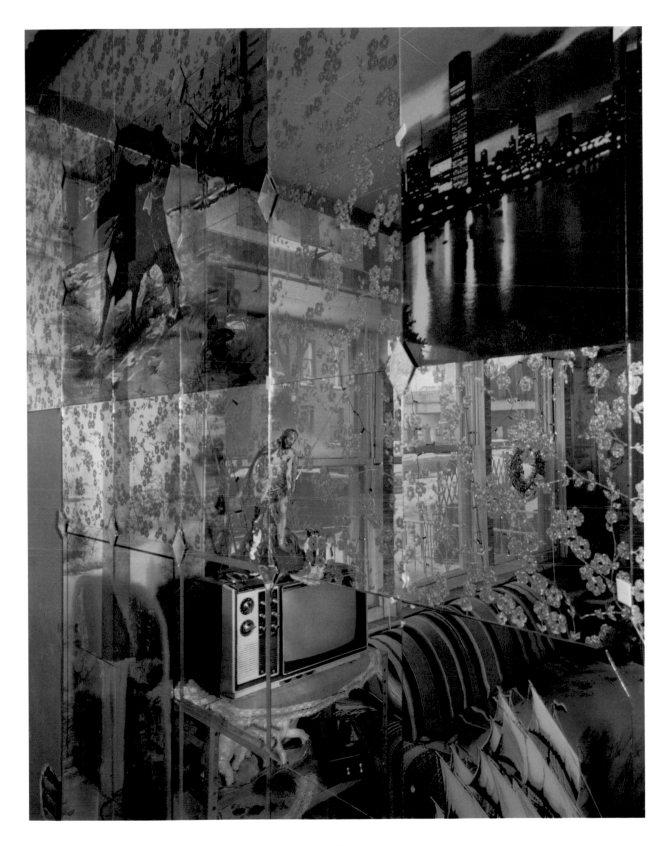

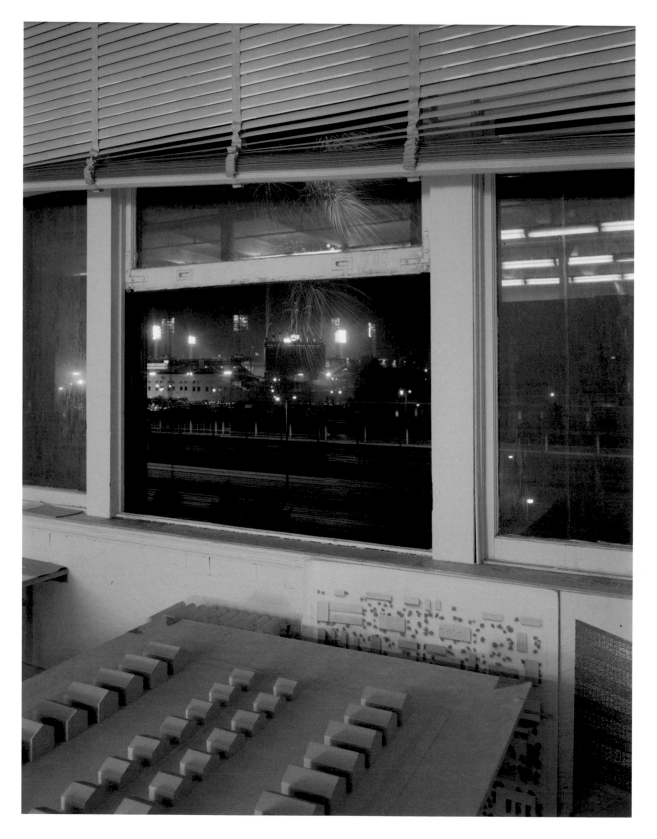

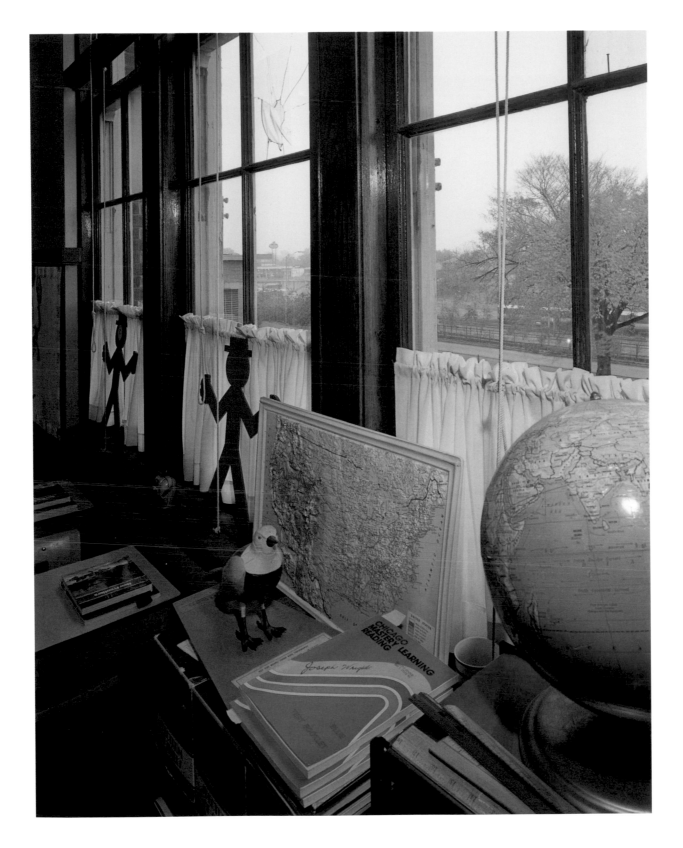

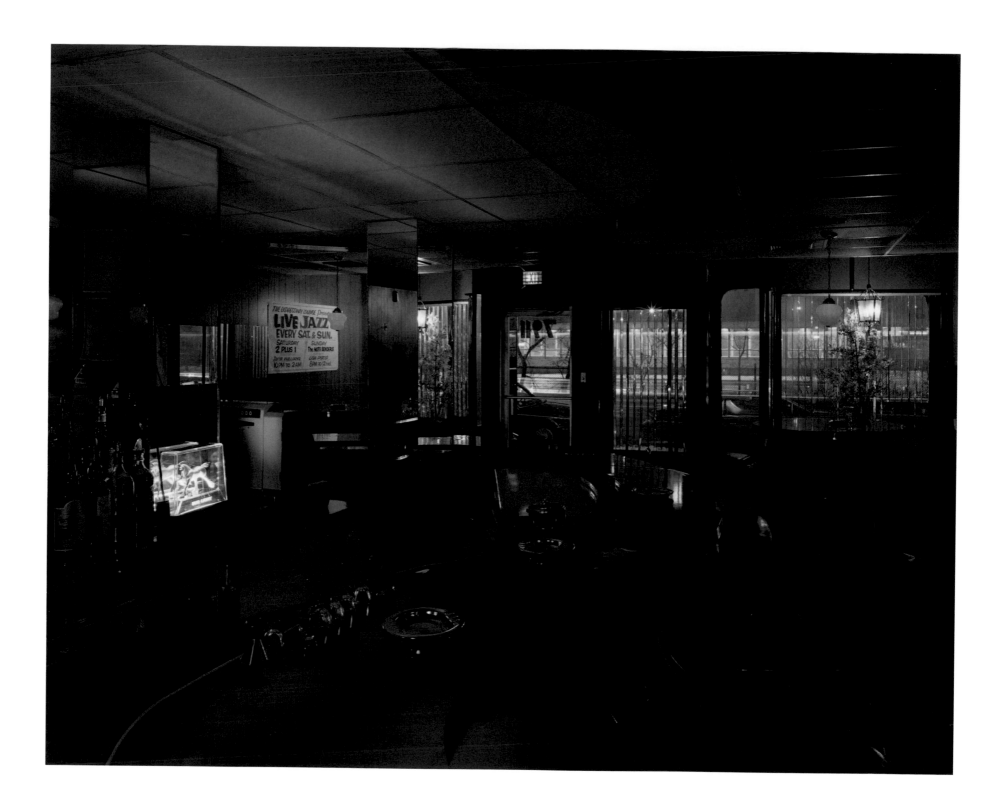

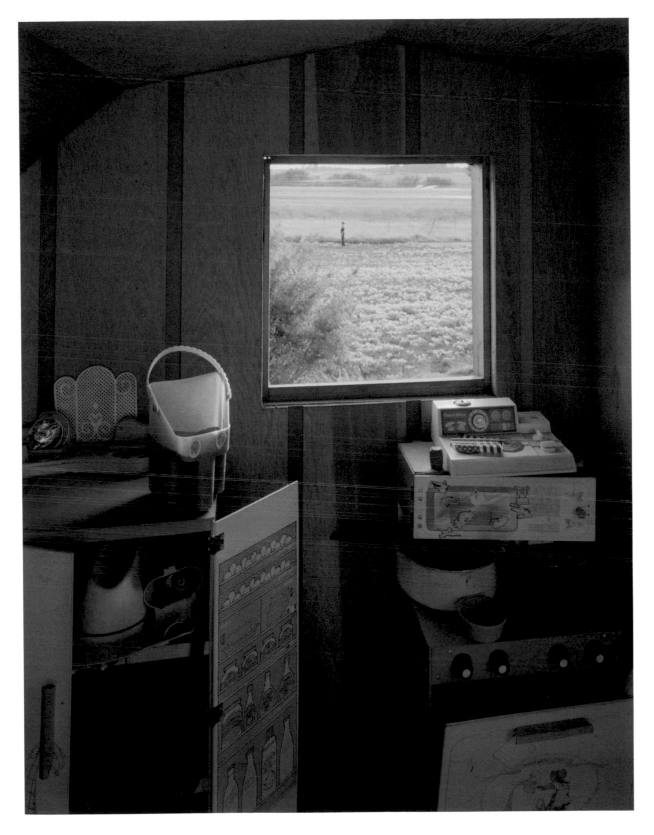

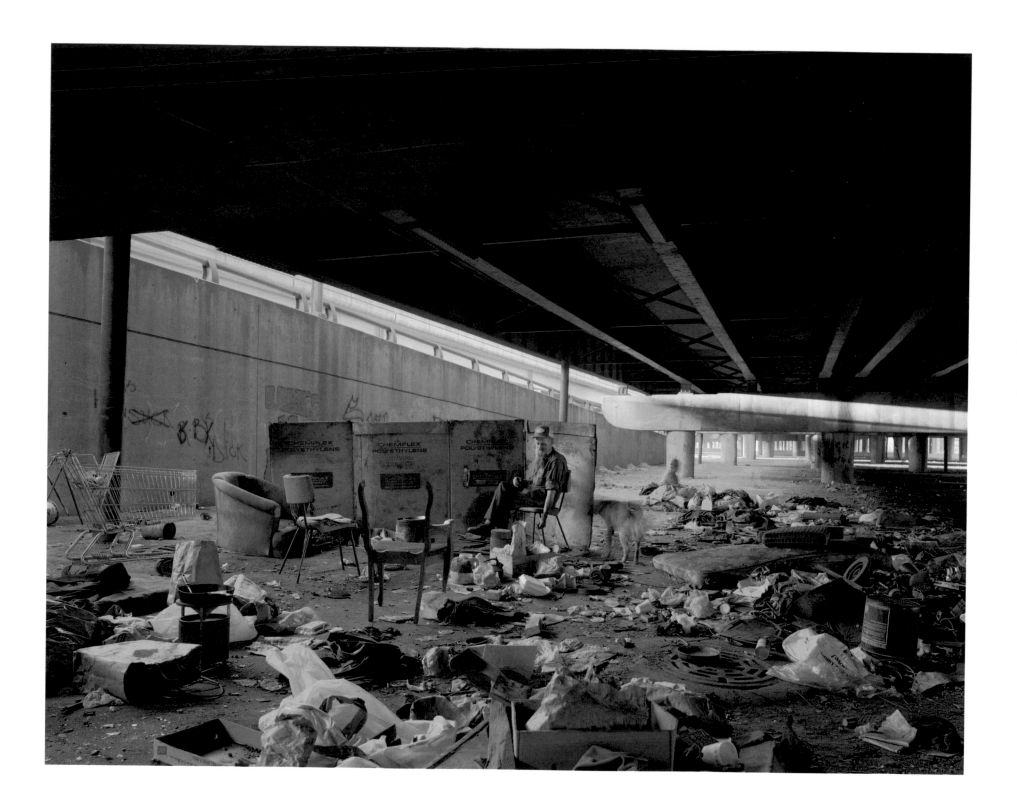

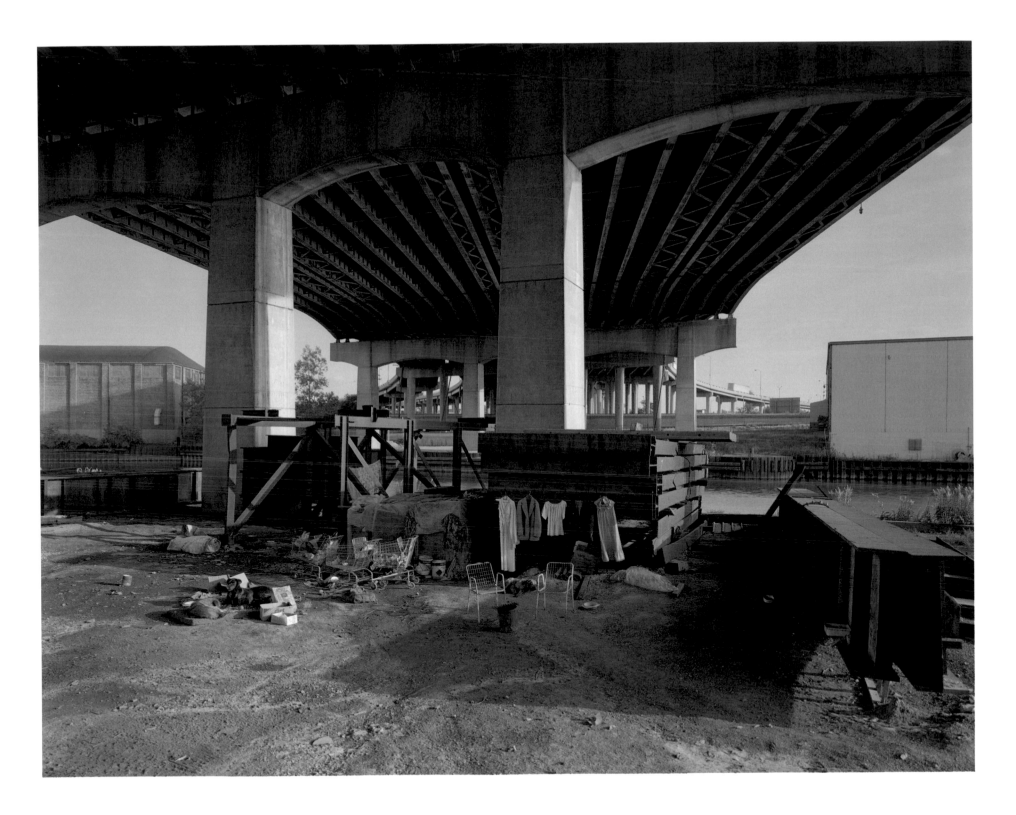

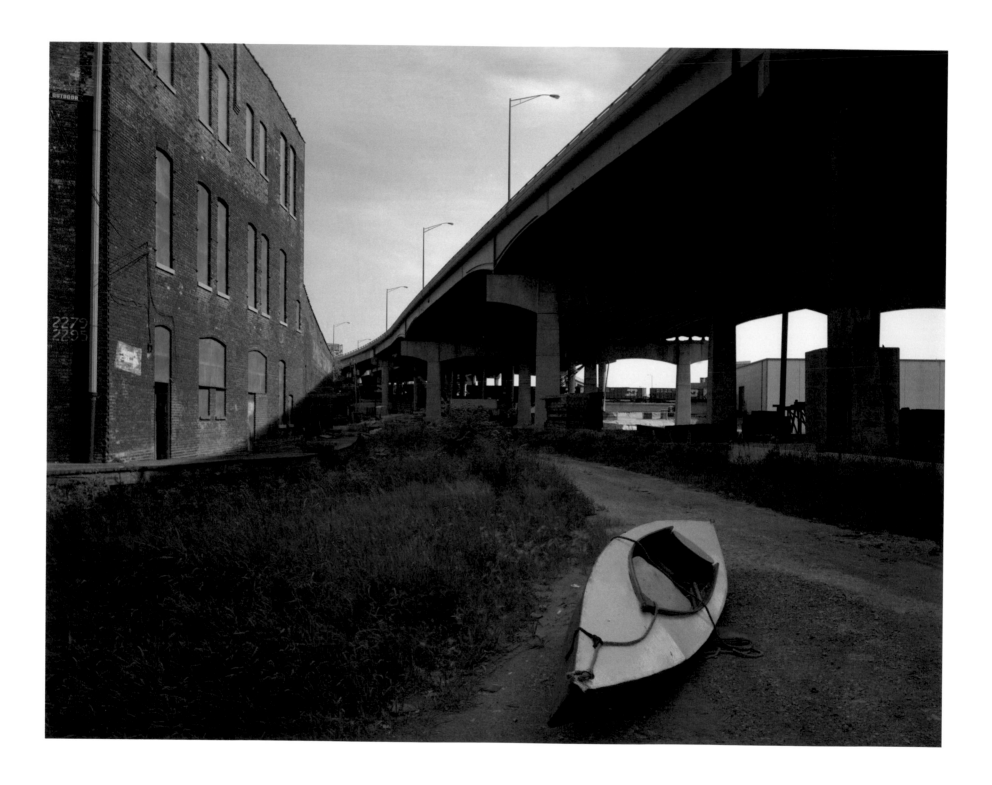

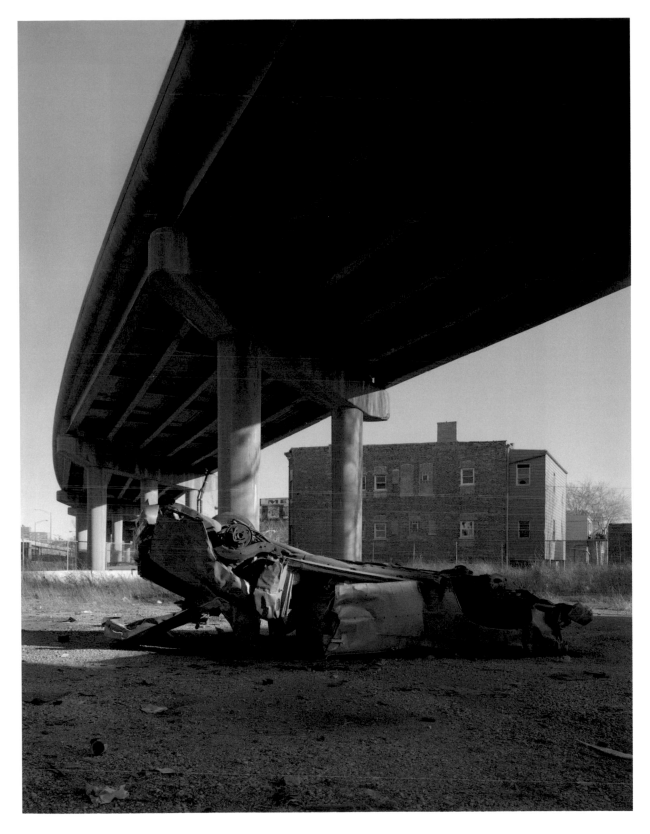

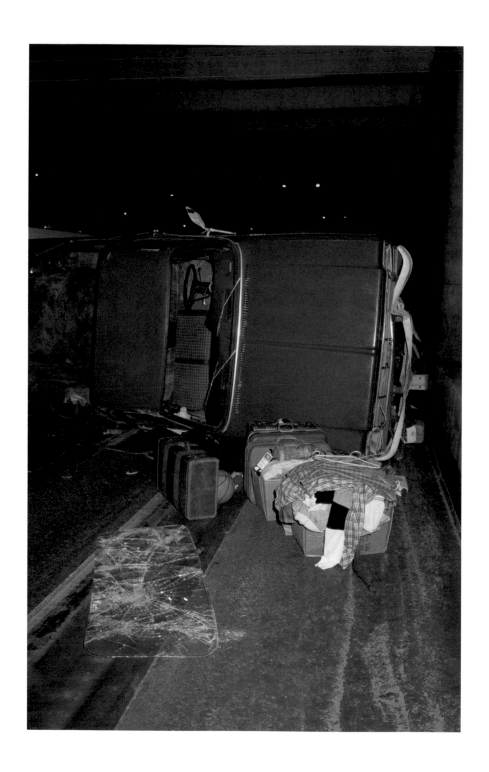

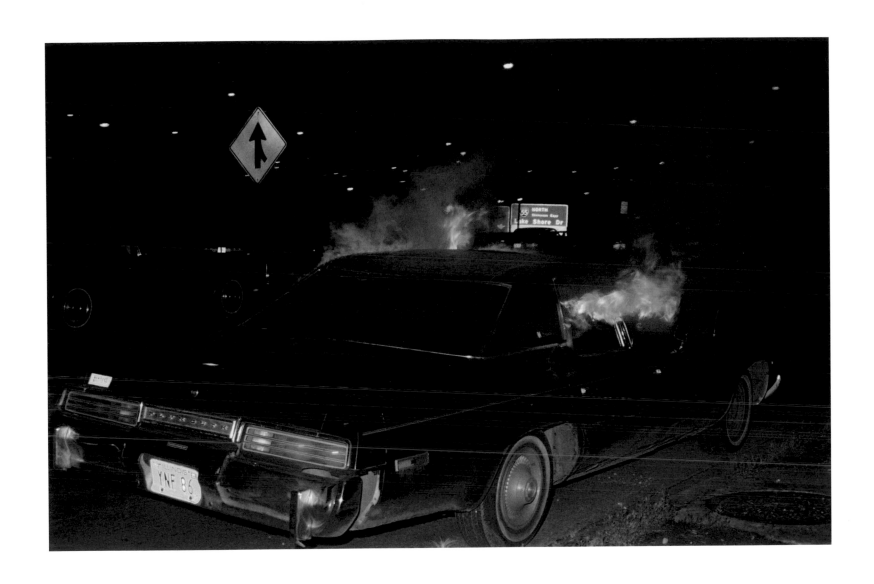

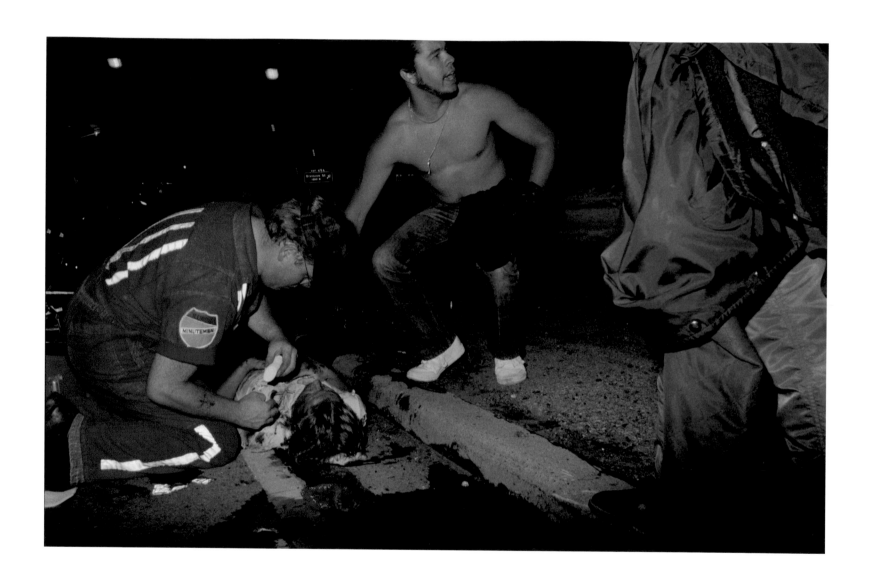

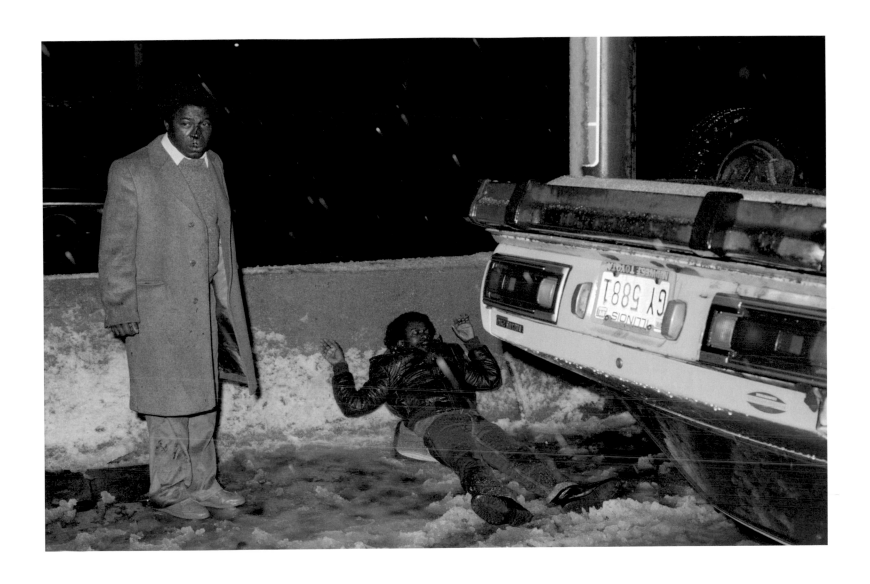

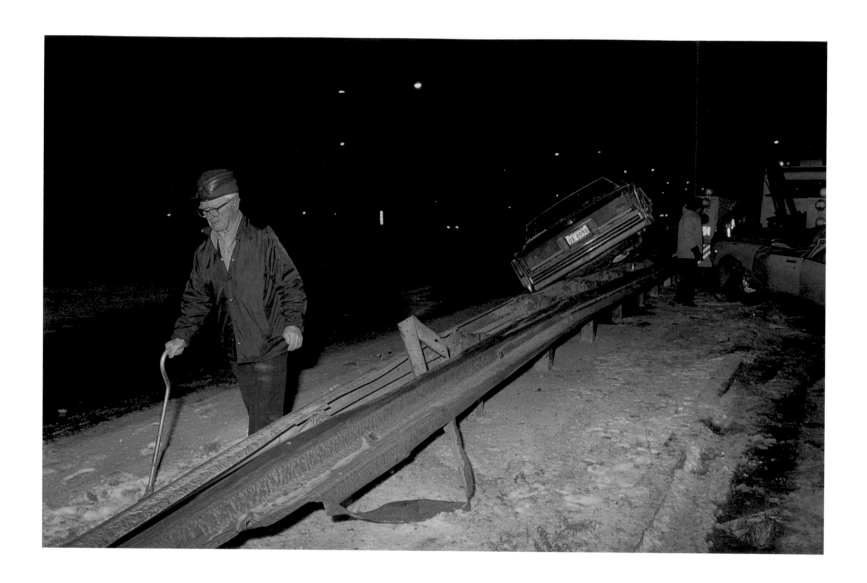

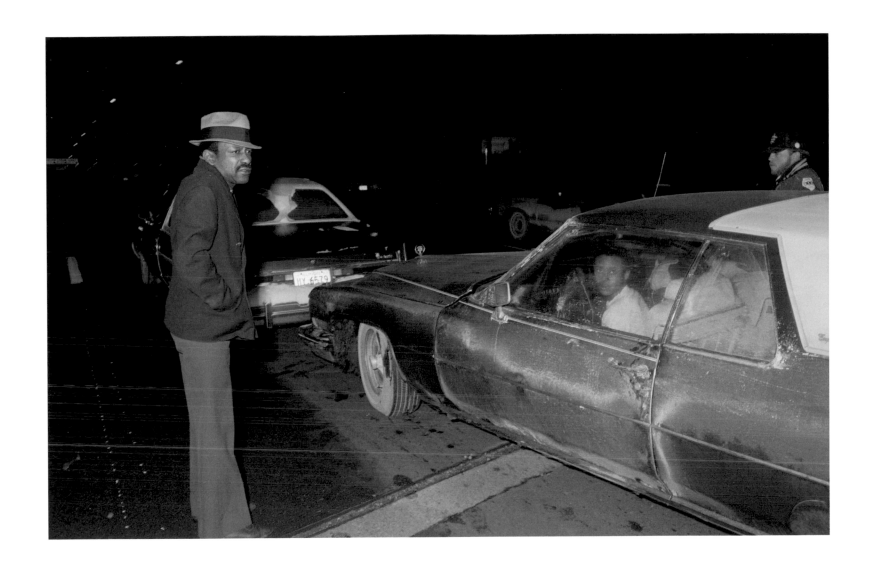

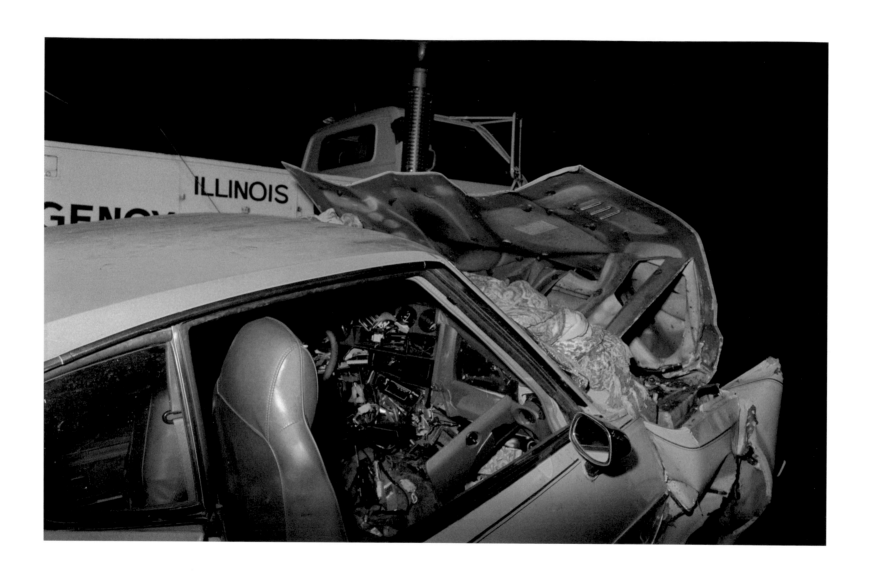

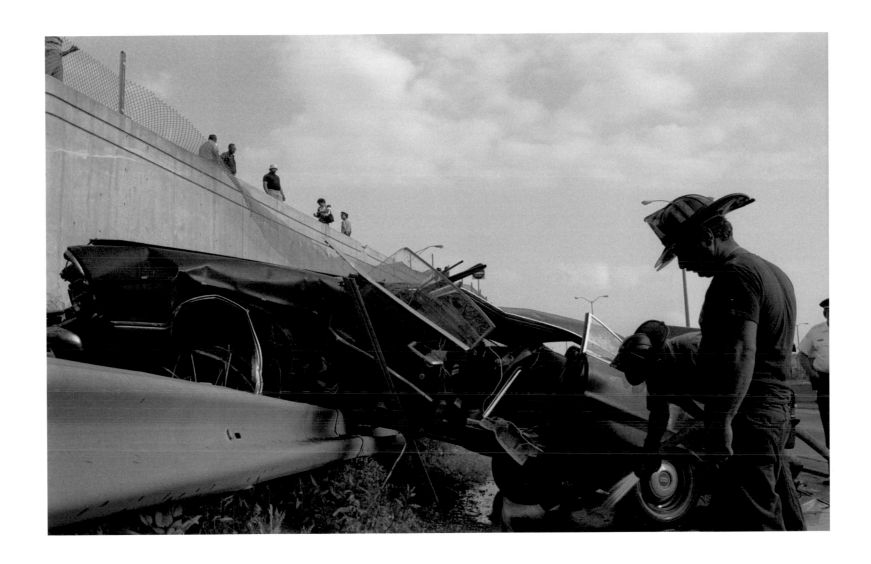

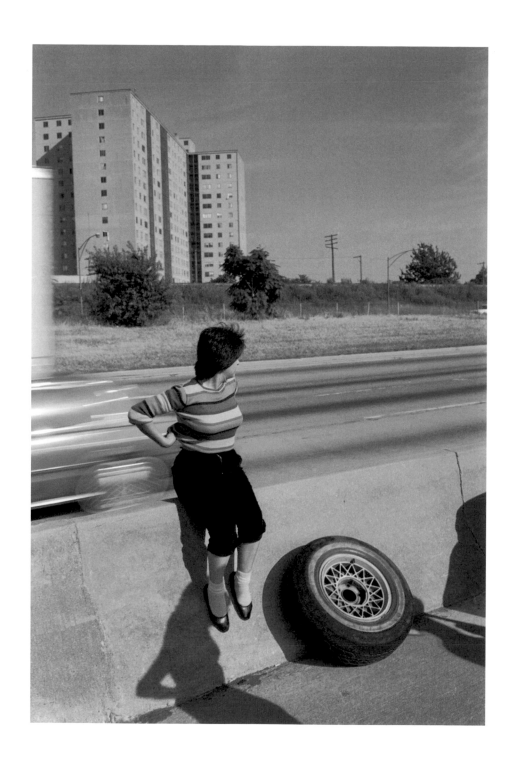

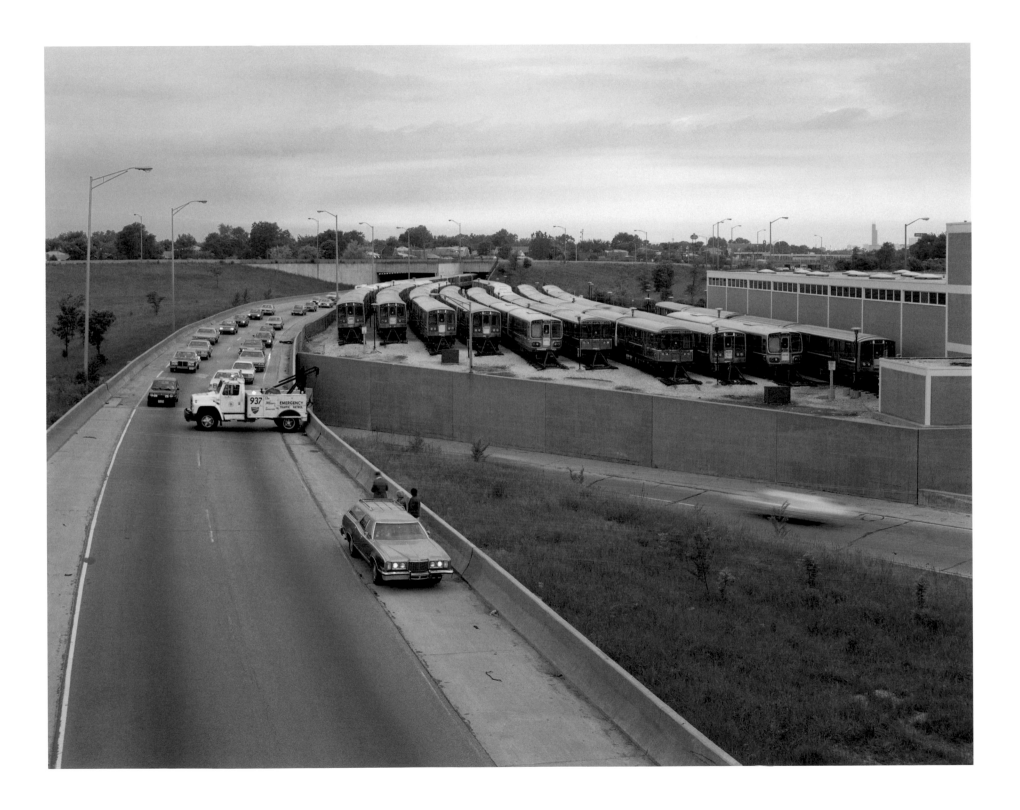

# The Busiest, the Most Dangerous, the Dan Ryan

**Dominic A. Pacyga**

South from the Loop to 95th Street the Dan Ryan Expressway roars across the city like a giant concrete and asphalt river. For most of its trip the road runs just slightly submerged beneath the city's street grade, but for part of it the Dan Ryan soars above old neighborhoods on incredible bridges that cast their shadow on the Chicago that still exists below. Homes, churches, schools, and parts of neighborhoods disappeared in the wake of the Dan Ryan as planners and engineers sent wrecking and construction crews to blast their way across Chicago's South Side, creating this most daunting of urban America's expressways. After 95th Street the expressway splits in two, running both southeast and southwest to create two other expressways that connect Chicago's South Side and Loop with the rest of the nation. Hundreds of thousands of cars, trucks, and buses spill along this huge gash that restructured the demographic and social realities of the city even before its opening. The Red Line, a rapid transit rail line, races through the center of the Dan Ryan. It brings yet more people into and out of the downtown area every morning and evening during rush hours, providing a vital public transportation link for the many neighborhoods huddled along the urban spine that the Dan Ryan has become.

For generations of Chicagoans the "Ryan" looks as if it is almost a force of nature, as natural as the prairie or the lake. The expressway seems to have always been there. It is simply a part of the landscape, providing another marker on the mental maps of most Chicagoans. The roar of the traffic becomes a sound that one gets used to, traffic jams and accidents something that are part and parcel of living in an American city. Nothing really beautiful or ugly exists here; it is simply an expressway. Jay Wolke, however, has brought the careful eye of the artist and the mind of the keen observer to the banks of the Dan Ryan. His photographs tell the very human story of the road in all its beauty,

ugliness, terror, and even normalness. Wolke has used the day-to-day life of the express-way to speak of the urban human condition at the end of the twentieth century. These beautifully executed photographs tell a story often ignored by those busy Chicagoans making their way back and forth across America's third-largest city. Wolke has found the city's tale in the Dan Ryan as it spills across the urban landscape. The Dan Ryan's story is Chicago's story in the post–World War II era.

The Dan Ryan Expressway officially opened on Saturday, December 15, 1962. Mayor Richard J. Daley, along with Ruby Ryan, the widow of the late Cook County Board President and expressway advocate Dan Ryan, and various other notables, including Governor Otto Kerner and Federal Public Road Administrator Rex M. Whitton, cut the ribbon at 18th Street. Mayor Daley and his entourage were the first to "officially" drive the Ryan, making their way south to 63rd Street and then back north to the Prudential Building for a celebratory luncheon. Mayor Daley had recently been quoted as expressing some doubts about whether it was such a good idea to keep cutting up the city to build such roads. On the day of the ribbon cutting, however, he praised the memory of the late Dan Ryan and the vision of President John F. Kennedy for their work on behalf of better roads. He might also have mentioned President Dwight D. Eisenhower, who passed land-mark legislation promoting and funding highway construction in 1956. Thanks to the Eisenhower administration and Congress, the federal government picked up ninety percent of the cost of the Dan Ryan and the rest of the massive interstate system that proved to be the largest public works project in the nation's history.

The day before the dedication of the Dan Ryan, Daley had announced his decision to run for a third term as Chicago's mayor. The Dan Ryan's opening fit well into Daley's percep-tion of his role as a city builder. Just to the east, the public housing towers of the Stateway Gardens, which had opened in 1958, and those of the Robert Taylor Homes, which opened along with the Ryan in 1962, looked down on the new expressway. All were part of Daley's legacy as the creator of modern Chicago. At the dedication Governor Kerner claimed that the Ryan gave Chicago and its suburbs "the finest system of express-ways in any city in the world." Rex Whitton described the Ryan as a keystone of the new interstate highway system that he claimed had saved 2,000 lives in 1961 alone.

Meanwhile one Chicagoan tried to take advantage of the celebration by moving his catering truck as close to the ceremony as possible. After the police turned Milton Smith of Chicago's Woodlawn neighborhood away from entering the Dan Ryan to sell coffee and rolls to the crowd gathering at 18th Street, he entered the expressway on the exit ramp at 18th Street going in the wrong direction. Smith was stopped and he tried to bluff his way out of trouble by claiming he had permission to enter the expressway to sell his products. In turn, the police charged Smith with driving the wrong way on a one-way street, failure to have a city sticker, and disorderly conduct. Milton Smith holds the dubious distinction of being the first driver to get a ticket on the Dan Ryan.

Moments after the ribbon cutting, Chicago motorists filled the expressway. Many simply came out to see the new road. The first accident occurred when Francis Doyle of the 8700 block of South Wood Street slid into a guardrail on the east side of the express lanes after his right rear tire blew out. Neither Doyle nor his wife and three children were hurt. The Doyles' first ride on the new expressway proved to be one they would never forget. Police reported ten minor accidents in the evening rush hour on the Monday after the opening.

As any Chicagoan who has ever tripped down an entrance ramp and joined the dance on the Dan Ryan can attest, driving on the "world's busiest" expressway can be both a frustrating and harrowing experience. It can also be the best way to get around in a city long known for its clogged streets and dangerous drivers. Terrence T. Doherty, Chicago's chief of the Police Traffic Division, warned from the outset that "Motorists will have to read signs carefully and, better still, study maps…." Less than a year after the road opened the often-quoted advice about how to learn to drive on the Dan Ryan appeared in the *Chicago Sun-Times*: "Someone said, it is best to stay off of it until you have been on it three times. That would mean never getting on at all." Eleven people had died on the 204-million-dollar Dan Ryan in the first seven months of 1963. In that same year Roger F. Nusbaum, deputy chief state highway engineer, claimed that "Expressways are safer than city streets." Despite the public perception that from its beginning the Dan Ryan was a consumer of commuters, reports stated that the Dan Ryan was comparable in

safety to the Congress Expressway (now known as the Eisenhower) and was safer than the Northwest Expressway (now the Kennedy).

At the onset the expressway's design seemed problematic. When the Ryan was built state engineers felt that shoulders were unnecessary on roadways that were built on bridges. The Dan Ryan quickly proved them wrong, and less than a year after the South Side expressway's opening they changed their minds and required ten- to eleven-foot shoulders on future structures as well as on surface roads. The very size of the Dan Ryan seemed confusing to drivers. At its opening the Dan Ryan was the world's widest expressway with fourteen lanes spanning much of its 11.6-mile length. When officials dedicated the Dan Ryan, State Highway Division officials proudly noted that it was the first time a highway had opened with full signage. Those green-and-white signs that direct traffic stood in place on the first day. Actually, almost all of the signs were in place. On opening day construction crews closed two lanes to put up more signs, causing the Ryan's first traffic jam. Construction projects resulted in backups on the Dan Ryan from day one. The signage and the Ryan's width, while designed to keep traffic moving, seemed at first to confuse drivers. Chicagoans, not yet used to driving on the massive highway, slowed down or even stopped to get their bearings, causing rear-end collisions.

Between 27th and 63rd streets the Dan Ryan Expressway is composed of four inner express lanes and three outer collector/distributor lanes. Add to that sixty-one on- and off-ramps from 31st Street south to I-57 and cars traveling at high speeds and the confusion can be disastrous for the novice driver. When the Ryan opened, a huge advertising sign at the 26th Street bifurcation increased the confusion as motorists complained that they were nearly blinded by its lights. In the months after Mayor Daley's inaugural trip roughly 130,000 vehicles flowed across its fourteen lanes every day. Trucks and other commercial vehicles made up fourteen percent of the traffic. Those numbers would soon be surpassed and then surpassed again and again. The *Chicago Sun-Times* reported that "… the motorist does not see the signs he must see to stay out of trouble. There are too many things rushing at him." One commentator suggested that the only answer was a beam controlling cars as they made their way on the road.

The opening of the Dan Ryan immediately resulted in slowdowns and traffic jams as motorists approached the Loop for the simple reason that the connectors to other expressways and Lake Shore Drive were not yet complete. The access and egress roads still hung in the air awaiting further construction. Almost immediately a Franklin Street Extension was proposed to allow cars to reach the downtown area. The full project never materialized, but the exit to 22nd Street and the eventual connection to the Stevenson Expressway and Lake Shore Drive provided much the same answer to the Ryan slowdown north of the old Comiskey Park. Several days after the expressway's opening, Leo C. Wilkie, of the Cook County Highway Department, commented on the problem of rush hour traffic jams, pointing out that it was economically and politically impossible to build an expressway system adequate to move traffic at rush hour levels. Despite clogged lanes and sometimes dangerous driving conditions, Chicagoans immediately embraced the expressway. Matthew C. Sielski, director of safety and traffic engineer for the Chicago Motor Club, announced a study showing that, in less than one month, the Dan Ryan was changing traffic flows across the South Side. Sielski pointed out that the Dan Ryan drew drivers at rush hours and unclogged other city streets making travel even on these faster and safer. A driver taking State Street from 67th to Congress Parkway after the expressway's opening saw his or her driving time cut by more than half. Traffic patterns had changed dramatically.

The issue of traffic flow on the expressway continued and still continues. In 1967 the city installed a computer to control traffic on the on-ramps during rush hour. The computer regulated traffic lights to provide for the even flow of traffic entering the Ryan. The lights were installed between 67th and 99th streets. At that time the western jog of the expressway was still considered part of the Dan Ryan; today it is part of I-57. Traffic engineers claimed the computerized system would save Southsiders seven or eight minutes off their commute. The traffic light system cost $125,000. Two years later work began on an underground electrical surveillance system on the highway between 99th Street and the Eisenhower Expressway. The west leg of the Dan Ryan opened in part

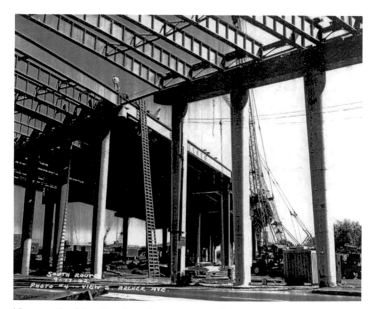

View south of the Dan Ryan Expressway under construction, then known as the South Route Expressway, from Archer Avenue on 17 September 1962. Photo courtesy of the Gibson Studio of Chicago.

in 1967, pushing the expressway from 99th and Halsted to 127th and Ashland. State engineers hoped to have the expressway reach 167th and Kilpatrick the following year, where it would tie into I-57 and the entire interstate system being built to the southwest of the city. This bit of expressway would cost more than ninety million dollars, as it cut through farmland and connected to newly developing suburban areas.

The extensions made it possible for more and more vehicles to enter the Dan Ryan. By 1973 nearly 200,000 cars and more than 36,000 trucks appeared daily on the expressway north of 63rd Street. The wear and tear on the road soon became very evident. In 1974 Langhorne Bond of the Illinois Department of Transportation remarked that the Dan Ryan between 14th and 103rd streets was carrying more traffic and supporting heavier loads than any other highway in the nation or even the world. Bond acknowledged that planners were "way off" on their traffic estimates when planning the expressway in 1958. Planners originally designed the Dan Ryan to handle 142,000 cars and 7,400 trucks daily. They believed that those numbers would not be exceeded until 1975 and that no repaving would be needed until 1982. The heavy truck traffic proved to be especially problematic for the expressway. Engineers estimated that a small truck did as much wear and tear on the expressway's pavement as 300 cars. A tractor trailer had the same impact on the asphalt as 2,900 cars. Between 1967 and 1974 the state paid 7.5 million dollars for repairs. In 1974 a 22.5-million-dollar repair project was announced. By 1975 the Dan Ryan handled 250,000 cars per day. Chicago Traffic Officer Richard Wiser simply summed it up, "It's not at all well designed." Even the huge structures that lifted the Ryan above the South Side felt the impact of intense use. In 1973 emergency crews jacked up two sunken forty-foot sections of the Dan Ryan at 23rd Street. Crews used fifteen 100-ton hydraulic jacks placed atop a newly constructed steel framework erected under the sunken section. The steel frame was designed to hold three million pounds, and the sunken part of the Ryan had to be lifted twelve inches. Even road repair could take on enormous proportions on the world's busiest highway. By this time the Dan Ryan had the unchallenged record of being the most dangerous highway in Chicago with 5,478 accidents in 1972, nearly five times the number on the Calumet Expressway (now the Bishop Ford) and 1,648 more than the Kennedy during the same time period.

Other issues besides heavy traffic soon made themselves evident on this most urban of highways. The Dan Ryan cut through heavily populated parts of Chicago. When it opened the *Chicago Defender* said it "knifes through the Negro community." Some of the city's poorest neighborhoods and most important institutions bordered the road. Several neighborhoods literally disappeared as crews plowed through the middle of the South Side. Armour Square, Fuller Park, and the eastern portion of Englewood felt the impact the most. While legend and common perception have the placement of the Dan Ryan along Wentworth Avenue as part of a plot by Mayor Richard J. Daley and white aldermen to somehow contain the city's growing African American population behind its traditional borders, a quick look at the demographics of the 1950s when the Ryan was planned shows a different reality. White as well as black and semi-integrated (that is, changing) neighborhoods stood in the path of the new expressway. If anything, construction hastened racial change not only near the expressway, but also across the South Side. The racial wall was breached long before and afterward in the southern half of Armour Square, Fuller Park, and the other "Between the Tracks" neighborhoods that stood in the Ryan's path. If Englewood's whites hoped that the Ryan would prevent minorities from entering their neighborhood, they were surely and quickly disappointed.

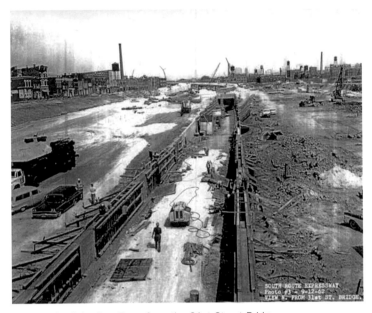

View north of the Dan Ryan from the 31st Street Bridge on 12 September 1962. Photo courtesy of the Gibson Studio of Chicago.

The same could be said for the host of neighborhoods south and southwest of Englewood. In the cases of Bridgeport and Canaryville, both located in Daley's white working-class 11th Ward, the expressway made little difference. Political power, railroad viaducts, and rail yards provided a much greater obstacle as did white street gangs. The expressway followed poor and working-class white and minority neighborhoods into Chicago just as interstates did across the United States. It was simply cheaper that way, and engineers often spoke about removing slums as one of the positive results of highway construction. One person's slum is another's neighborhood. This was certainly true on the South Side. The original plan did call for the Dan Ryan to be built a few blocks farther to the west along Normal Avenue. This would have the massive highway running through the eastern section of Bridgeport and through the heart of Daley's 11th Ward, the route originally supported by the newly elected Mayor Daley in 1955. It was basically the

same plan that had been proposed by the city council and endorsed by the county, state, and federal governments before World War II. Daley's commissioner of public works, George DeMent, went over the plans and approved them. A year later, however, the proposed highway route was changed to cut between Wentworth Avenue and Wells Street to the east of Bridgeport and the 11th Ward. DeMent presented the new route to the City Council, which quickly approved it. Racial concerns aside, Daley was hardly going to allow an expressway to destroy his home ward and political base. After a year in office Mayor Daley had the plans changed.

Indeed the highway system had dissected both white and black neighborhoods in Chicago. The building of the Kennedy Expressway resulted in the removal of some 400 Polish families in the parish of St. Stanislaus Kostka, the first Polish parish organized in Chicago. Polish American politicians led by Congressman Dan Rostenkowski could not stop the expressway's construction, but they could have it moved slightly to prevent the destruction of their beloved church on Noble Street. Today the expressway passes just beneath the rectory window of St. Stan's. West Side Italians fared much worse. Holy Guardian Angel Parish was right in the path of the proposed Dan Ryan Expressway. In 1959 parishioners celebrated the last Mass in the church on West Arthington Street, just east of Halsted Street. Parishioners built a new parish complex at 860 West Cabrini Street. Four years later crews demolished the new Italian church to clear the neighborhood for the new University of Illinois campus in Chicago. Urban renewal and expressway development trumped the concerns of all kinds of communities in "Clout City."

The new route of the Dan Ryan surged along a corridor framed by railroad lines that served the Loop and the nearby Union Stock Yards. Two long narrow community areas stretching south from 18th Street to Garfield Boulevard (55th Street) between the Rock Island and New York Central Railroad embankment to the east and the old Pennsylvania Railroad yards to the west took the brunt of the Dan Ryan's construction. The northernmost neighborhood, Armour Square, was the locality of old Comiskey Park, home of the Chicago White Sox baseball team. It also contained Chinatown and large Italian and Croatian communities.

In 1920, twenty-three percent of Armour Square's population was black. By 1950 African Americans made up forty-seven percent of the area's population. Mexicans also had a large presence in the neighborhood. Construction of the Dan Ryan took place through the eastern portion of the neighborhood. It cut through just to the east of Comiskey Park and removed a good deal of the African American population. Most Chicagoans see Armour Square as just an appendage to Bridgeport, and it is here that the idea first emerged that the expressway was built as a wall to keep blacks out. The African American population fell by more than fifty percent in a district that saw its total population decline by just over thirty-two percent. The black population became heavily concentrated in the southern portion of the community in and around the Wentworth Garden Apartments, a housing project built in 1946 on the site of the original Sox Park, which was also the home of the Negro League's Chicago American Giants baseball team.

To the south of Pershing Road (39th Street) and Armour Square is Fuller Park. Here, too, the Dan Ryan had a dramatic impact. Fuller Park saw its population decline by just under 5,000 residents between 1950 and 1960. In 1950 blacks made up fifty percent of the population. Austrian and Irish ethnics made up a large part of the white population. St. George Roman Catholic Parish proved to be the community hub for Austrians while St. Cecelia provided a home for the Irish. By 1960, as Dan Ryan construction crews moved through the district, blacks made up ninety-six percent of residents. The expressway route was directed around both St. George's and St. Cecelia's. While the churches were spared, their neighborhoods were not. Seven years after the opening of the Dan Ryan, St. George's parish was combined with St. Cecelia's and wrecking crews demolished the old Austrian church. Three years later, less than a month before the Dan Ryan's tenth anniversary, St. Cecelia's closed its doors and the building was pulled down. In Englewood, just below Fuller Park, the expressway cut through two more important Catholic parishes, St. Ann's and St. Martin of Tours. Englewood's population grew during the construction of the expressway. The black population jumped dramatically from just over ten percent of all residents in 1950 to sixty-nine percent ten years later. The Wentworth Avenue boundary was hardly reinforced by the construction of the Dan Ryan

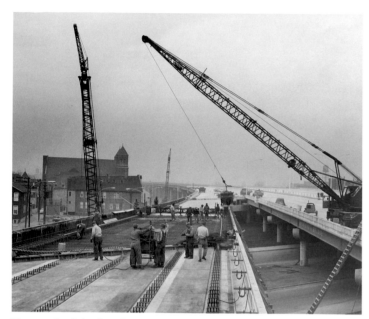

View north of the Dan Ryan over Canalport Avenue. 1962.
Photo courtesy of the Gibson Studio of Chicago.

Expressway. If the Dan Ryan was built as a racial wall, it was not a very good one, at least not south of 35th Street.

The physical impact of the expressway can be seen in the family histories of Chicagoans, both black and white, who lived in the path of the new roadway. The Jacksons moved to Chicago in 1952 from Mississippi as part of the second wave of the Great Migration, which changed the history of Black America forever. Angeline and George Jackson purchased a multi-unit home with a storefront on the 5500 block of South Wentworth the following year. They raised their nine children in the building, which looked across Wentworth at a pleasant shopping strip that included, as Mrs. Jackson recalled, a phonograph store that played Sam Cook records and piped them out to the street. On the corner across from St. Anne's Catholic Church, where the Jacksons worshiped, stood the Uptown Pharmacy, an African American–owned business sometimes called the "Jazz" drug store because the owners were also jazz musicians. A white-owned pharmacy stood nearby and catered to white customers in this still-integrated neighborhood. The Jackson boys played football on the grassy boulevard in front of St. Anne's and the Uptown. All in all it was a fairly comfortable urban world. Then came the Dan Ryan and the Wentworth Avenue shopping strip disappeared, as did the swath of boulevard. The Uptown Pharmacy moved away. Suddenly the neighborhood in front of the Jackson's house was gone. The prairie returned temporarily and then came the great gash of the expressway. The Jacksons now lived just off the Garfield Boulevard exit ramp of the mighty Dan Ryan Expressway. For the Jacksons the whole orientation of the neighborhood shifted from west to east. In 1971 St. Anne's merged with the St. Cecilia and St. George churches to create a new parish, St. Charles Lawanga, named after a Ugandan Catholic martyr.

Just to the south in the Catholic parish of St. Martin of Tours, racial change was well on its way even before the expressway came through the neighborhood. After expressway construction the beautiful German Gothic structure, with its gold-painted statue of St. Martin riding a horse atop the peak of the roof, looked down on a truncated neighborhood and the fourteen lanes of the Dan Ryan Expressway. St. Ann's Church is gone. St. Martin's church now serves a black Protestant congregation. The expressway still

hums under the gaze of St. Martin on his horse. Farther south the old State Street market at 71st Street was essentially destroyed by highway construction; only a small remnant remains along the west side of State Street. At the northern edge of the Dan Ryan the road had a major effect on the Maxwell Street market, pushing what was left of the old immigrant street farther west and placing the huge cement and traffic wall to its east. After the Dan Ryan's dedication, Mayor Daley proposed that Maxwell Street should be cut back even more. The venerable old street tradition held on until the dawn of a new century, but even in the late 1950s city planners were eager to rid the city of what they considered an old-fashioned eyesore.

There was little organized opposition to the building of the Dan Ryan. Certainly nothing like the later protests that stopped plans for the Cross Town Expressway in the 1970s. Catholic Church leaders bemoaned the destruction of neighborhoods by expressway construction and massive urban projects such as the makeover of Hyde Park and the removal of poor residents from that district around the University of Chicago, but little was done to prevent it. Mayor Richard J. Daley saw this and other projects as beneficial to the city. Chicago was to be a new modern city, and expressways provided an important part of that vision. From the beginning a rapid transit rail line was planned to run down the center of the Dan Ryan, providing easy access to the Loop. The line designed by one of the few women civil and traffic engineers in the country, Elizabeth Jackson McClean, opened in 1969. Large high-rise projects built along the road and transit line pointed to the modernist dreams of Le Corbusier and the Bauhaus. Experts built the Dan Ryan Expressway, and they saw a bright new world emerging out of the dirt and disorder of the old industrial city. Daley, despite his Bridgeport and neighborhood provincialism, embraced this modernist worldview. Daley, the builder, saw new airports, housing projects, and the highways as projects that brought Chicago into the new high-tech world emerging through the prosperity of the postwar era. Experts were to be trusted and growth was good.

Urban problems began immediately to have an impact on the roadway. Less than five years after the expressway's dedication, the *Chicago Sun-Times* reported on hazards

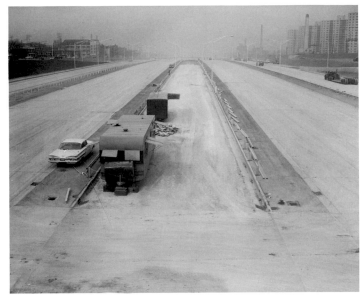

View north of the Dan Ryan with the Robert Taylor Homes to the east. 1962. Photo courtesy of the Gibson Studio of Chicago..

beyond the imagination of the engineers who had planned the massive public works project. The newspaper warned that not only did drivers have to watch out for speeding and careless drivers, but also for vandals who stood on the overpasses and "bombed" cars with rocks, bricks, and other heavy debris. In May 1967 Public Works Commissioner Milton Pikarsky asked the City Council Finance Committee to approve eight-foot-high chain link fences to protect drivers on both the Dan Ryan and the Eisenhower expressways. Pikarsky could not, however, build a fence to round up the occasional steer, hog, or sheep that broke free from a truck making its way to the nearby stockyards. Life is anything but dull on the Dan Ryan.

While the building of the expressway had seen little protest, the 1960s brought other disputes and demands to the banks of the Dan Ryan. As the Civil Rights Movement raised consciousness, African Americans began to demand their share of good-paying construction jobs. In July 1969, demonstrators halted construction of the Dan Ryan Rapid Transit Line between 35th and 63rd streets. The Coalition for United Community Action, led by the Reverend C.T. Vivian and David Reed, called for more jobs for minority workers on the rapid transit project and at other construction sites across the city. One hundred demonstrators took part in the protest that started during the morning rush hour and temporarily stopped work at the 51st Street rapid transit station. About seventy-five Chicago police officers stopped the demonstrators at the 35th Street station. They then marched east on 35th Street to a building construction spot, protesting the lack of minority workers on that job site in the middle of the African American community. Five years later a coalition of Latinos and African Americans protested the lack of jobs for their communities on the Dan Ryan's massive repair and repaving project. Construction firms moved to end the protests by promising the hiring of more minorities.

The Dan Ryan is now more than forty years old and as many as 300,000 vehicles travel the road each day. Roughly eighteen percent of those are trucks. While much change has come to the Ryan and the neighborhoods bordering it, the stress of driving the expressway remains. Between the years 2000 and 2003 more than 7,800 accidents took place, resulting in thirty-two deaths. By 2001 the Chicago and Northwest Indiana corridor, with

the Dan Ryan at its heart, ranked as the fifth most congested urban area in the nation. In the spring of 2003 the State of Illinois announced a major reconstruction of the Dan Ryan from 31st Street south to I-57 at a cost of some 400 million dollars. While the project was hailed as a major renovation, it quickly brought controversy in its wake. Planners called for the closing of twelve on- and off-ramps. Residents from the predominantly African American communities adjacent to the Dan Ryan protested, claiming that the changes would further isolate and harm their neighborhoods. Many saw the plan as an attack on inner-city neighborhoods in order to make commuting to the suburbs easier. These neighborhoods felt betrayed just as they saw the promise of new investment and renewal on the horizon, and once again minority hiring by the construction firms that were to rebuild the expressway became an issue. Neighborhood residents wanted jobs renovating the road. The Dan Ryan still sits at the center of the urban argument.

At the beginning of the twenty-first century the neighborhoods that border the mighty Ryan are in the midst of change. The old Maxwell Street market is gone and in its place is rising a new neighborhood, University Village, the result of the transformation of the Near West Side that began with the construction of the Dan Ryan and the campus of the University of Illinois at Chicago (UIC) in the 1960s. The sixty-eight-acre site has been developed with dormitories, academic buildings, townhouses, midrise residences, stores, restaurants, parks, and the other accoutrements of urban neighborhoods at a cost of about 700 million dollars. Two thousand Chicagoans are expected to live in University Village when it is completed in 2005. The sound of the blues will no longer come from Maxwell Street, but from the CD players of the new residents.

Just south of University Village change is also coming to Pilsen, especially east of Halsted Street, where the Ryan soars over the neighborhood as it makes its way south toward Bronzeville. The Ryan shoots past the twin towers of Providence of God Church, an old Lithuanian Catholic parish that now serves the city's largest Mexican community. Artists have made their home in the shadow of the expressway and art studios now line Halsted Street, bringing gentrification in their wake. The Mexican community worries about the

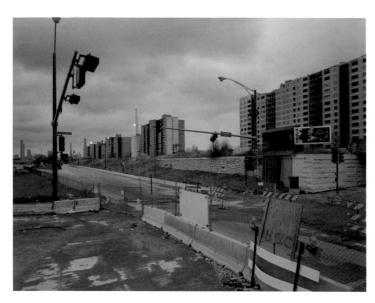

Demolition of the Robert Taylor Homes in 2003. © Jay Wolke

newcomers and their impact on Pilsen, which has always been a working-class immigrant gateway to the city, but like the old Maxwell Street neighborhood seems to be on the verge of changing into something very different.

As the Ryan moves farther south, change seems to follow it. Old Comiskey Park is gone, replaced by a new ballpark called U.S. Cellular Field. As a result of the 2003 Major League All Star Game, the 35th Street Bridge over the Ryan was adorned with fancy signs marking both the new Sox Park and the Illinois Institute of Technology. Soon a new Metra commuter station will open at 35th Street to serve both White Sox fans and new residents who will be attracted to the radical transformation taking place in the Bronzeville neighborhood just to the east of the expressway. Change in the urban landscape seems to be rushing all along the banks of the mighty Ryan.

The public housing towers that paralleled the expressway south of 35th Street are all but gone. New commercial and housing developments are promised up and down the State Street corridor. By 2010 more than 1,300 new housing units will be built on and near the site of the once-soaring buildings of Stateway Gardens and the Robert Taylor Homes. Bronzeville, the heart of Chicago's original African American community, is going through tremendous changes with investors and new residents restoring the old homes along Indiana, Michigan, and Wabash avenues. Change brings problems and controversy again. Where will the poor who filled the housing projects go as urban redevelopment moves across the South Side? Bridgeport and Chinatown, to the west, point the way to the new reality, as housing values and rents have soared in those neighborhoods, making them less affordable for their traditional working-class residents. Meanwhile the roar of the Dan Ryan continues night and day as Chicagoans and passersby make their way across the South Side.

Jay Wolke's photographs capture the life of the Dan Ryan. They tell the tale of the expressway, but like the history of the Dan Ryan they also reflect on the life of the city that it passes through. Here are photographs of this massive road as it flows into the colossal Chicago Circle that connects the Ryan, Kennedy, and Eisenhower expressways

just west of the Loop. Most Chicagoans simply refer to this vast accumulation of ramps, concrete dividers, and traffic lanes that seem endlessly to ring each other as the "spaghetti bowl," thinking that Chicago Circle was simply once the name of the nearby UIC campus. Wolke's photographs are taken from on and off the Dan Ryan, from within and on top of the buildings that line its fourteen-lane expanse. Wolke, with his finely honed artist's eye, has captured the day-to-day angst of the Dan Ryan. Here is the traffic jam, the car with perilously balanced mattresses perched on its top, the terror of an accident, the work of "Minute Men," paramedics, and firefighters who respond to the everyday problems of the Ryan. From the Dan Ryan drivers pass the glories of Chicago's architecture in the guise of the Sears Tower, the modernist campus of the Illinois Institute of Technology, and the other faithful monuments of the City of the Big Shoulders. Old Comiskey Park is even seen in these images, although the Dan Ryan itself, sadly, is not old enough to have ever handled traffic for a World Series game. Still in a city of optimism and opportunity that day may yet come.

Jay Wolke's photographs show the Dan Ryan in all its glory and in its sad desolation. Like Chicago, the Dan Ryan Expressway keeps doing its everyday job hoping for a better future. These photographs portray that optimism and reality in a city that still works.

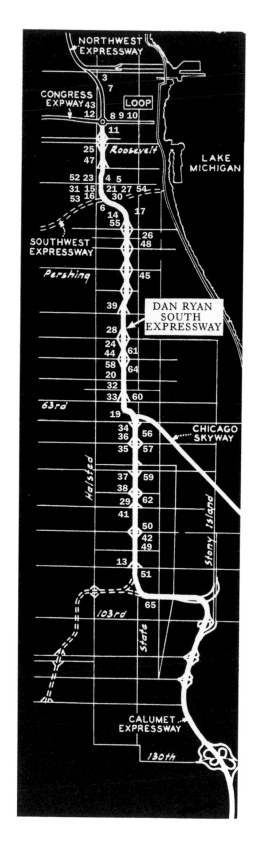

This map indicates the locations of the photographs in the book; they correspond to page numbers as presented in the *List of Plates* on page 83.

## List of Plates

## Acknowledgments

This project's existence is due to the efforts of many people over many years. My acknowledgments must begin with those who live, work, and travel along the Dan Ryan Expressway. They inspired my vision and became the source materials for these photographs. Thank you to all the people who allowed me access to their living rooms and rooftops, their schools and businesses. Also crucial to this production were the administrators and drivers of the Illinois Department of Transportation, who generously allowed me to ride along and document their great work. Minute Man Bobby Dilling was my primary guide, and I will always appreciate his friendship and courage (as well as his showing me the best place for ribs on the South Side).

The first and greatest institutional support for the Dan Ryan project was from the Chicago Historical Society and its Chief Curator of Photography, Larry Viskochil. Larry's encouragement and commitment first hardened my resolve to make these photographs and helped to facilitate access to many of the subjects depicted here. He mounted the first major exhibition of this work in 1985, and this show essentially established my career as a photographic artist.

Other key organizations instrumental in the original work's production and dissemination were the Illinois Arts Council and the National Endowment for the Arts/Great Lakes Arts Alliance.

The project's rebirth in the form of this book, *Along the Divide*, has also had many contributors. Crucial and generous support has come from Jeanne and Richard S. Press, Nancy and Ralph Segal, and Jack Jaffe. Dominic Pacyga's incredible knowledge and insights regarding the history of the Dan Ryan Expressway provided the finest essay a photographer could hope for. Special thanks, also, go to my friend Joel Sternfeld, whose inspiration and support extends to the time I produced this work and continues to this day.

Bob Thall, chairman of the Photography Department at Columbia College Chicago, and George F. Thompson, president and publisher of the Center for American Places, recognized these photographs as meaningful documents of American life. They had the faith and vision to suggest their publication and convinced me to produce the work in its current form. Their assistance in editing and developing the current narrative was instrumental. Bob and George have insisted upon the highest level of production standards and have shown the utmost regard for the spirit of these photographs. I could not ask for two greater collaborators and co-publishers.

Expert designers, technicians, researchers, and editors helped to make this book not only a wonderful artifact, but also an incredible process in which to be involved. Sarah Faust, the primary designer, under the leadership of Mary Johnson in Columbia's Office of Creative and Printing Services, has beautifully interpreted and transformed this material. Other members of Columbia's Photography and Art and Design departments who were directly involved in the digital reproduction, or who tutored me just enough to become dangerous at Photoshop, include: Bernie Sotolofski, Josh Lefley, Tammy Mercure, Jennifer Keats, and Tom Shirley. Equally important were copyeditor Christine DiThomas and research assistant Christy Karpinsky. My greatest thanks go to Ben Gest for his essential contributions in helping to revive and translate my original negatives into the revitalized form seen in this book. His exceptional abilities as a photographer, digital technician, and teacher have profoundly influenced this work and me.

Columbia College Chicago has also provided exceptional institutional and collegial support. I'd like to thank Dr. Warrick Carter, President, Steven Kapelke, Provost, Leonard Lehrer, Dean of the School of Fine and Performing Arts, and Mike DeSalle, Chief Financial Officer. Support and advice from all my friends and colleagues in the Art and Design Department kept me focused and sane during the entire production process. Most special thanks go to Sallie Gordon and Kevin Cassidy, and to Mary Griffin.

As with any photographic reproduction and publication, it is in the final iteration of ink on paper where a project's true content is realized. This reality was made possible by the outstanding professionalism of the individuals at Oddi Printing in Reykjavik, Iceland. Special thanks go to Steini Torfason, who made the days on press a most memorable and wonderful experience.

Thanks to Pam Schermer, Patty Carroll, Paul D'Amato, Mike Lagen, Norman Wald, Carey Goldenberg, Tony, Tommy, Cliff, and Fe, from whom I also received great technical and personal support. Special thanks to my parents Marshall and Estelle Wolke, Aunt Gertrude, and my brother Joe and sister Judy, who encouraged and supported my entire career.

Finally, I give the greatest acknowledgment and love to Avril Greenberg, my wife. Her insights nourish me daily and her strength revives me. When she likes a photograph, all's well.

## About the Author

Jay Wolke was born in 1954 in Chicago. He received a B.F.A. in printmaking and design at Washington University in St. Louis and completed an M.S. in photography at the Institute of Design, Illinois Institute of Technology in Chicago. Since 1981 he has taught photography and art at the School of the Art Institute of Chicago, the Institute of Design at IIT, Studio Art Centers International in Florence, Italy, and Columbia College Chicago, where since 2000 he has been chairman of the Art and Design Department. Wolke has had solo exhibitions at the Art Institute of Chicago, Harvard University, the Museum of Contemporary Photography, the St. Louis Art Museum, and Studio Marangoni in Florence, Italy. His photographs are in the permanent print collections of the Art Institute of Chicago, Brooklyn Museum, Minneapolis Museum of Art, Museum of Contemporary Photography, Museum of Modern Art, and St. Louis Museum of Art, among others. He is the author of *All Around the House: Photographs of American-Jewish Communal Life* (Art Institute of Chicago, 1998), and his photographs have appeared in many publications, including *Architectural Record*, *Fortune*, *Newsweek*, *New York Times Magazine*, and the *Village Voice*.

## About the Essayist

Dominic A. Pacyga was born in Chicago in 1949 and was raised in the Back of the Yards neighborhood on the city's South Side. He received a Ph.D. in history from the University of Illinois at Chicago in 1981. Pacyga has authored, or co-authored, numerous books, including *Chicago's Southeast Side* (1998) and *Polish Immigrants and Industrial Chicago: Workers on the South Side*, *1880–1922* (1991; 2003). He has lectured widely on topics ranging from urban development to labor history, immigration, and racial and ethnic relations. Most recently he acted as guest curator of a major exhibit, "The Chicago Bungalow," at the Chicago Architecture Foundation. He and Charles Shanabruch are co-editors of *The Chicago Bungalow* (2001). Pacyga has won the Oscar Halecki Award from the Polish American Historical Association, the Catholic Book Award, and the Columbia College Award for Excellence in Teaching. He joined the Liberal Education Department at Columbia College Chicago in 1984 and he is now a professor of history.

The Center for American Places is a tax-exempt 501(c)(3) nonprofit organization, founded in 1990, whose educational mission is to enhance the public's understanding of, appreciation for, and affection for the natural and built environment. Underpinning this mission is the belief that books provide an indispensible foundation for comprehending—and caring for—the places where we live, work, and explore. Books live. Books endure. Books make a difference. Books are gifts to civilization.

With offices in New Mexico and Virginia, Center editors bring to publication 20–25 books per year under the Center's own imprint or in association with publishing partners. The Center is also engaged in numerous other programs that emphasize the interpretation of *landscape* and *place* through art, literature, scholarship, exhibitions, and field research. The Center's Cotton Mather Library in Arthur, Nebraska, its Martha A. Strawn Photographic Library in Davidson, North Carolina, and a ten-acre reserve along the Santa Fe River in Florida are available as retreats upon request. The Center is also affiliated with the Rocky Mountain Land Library in Colorado.

The Center strives every day to make a difference through books, research, and education. For more information, please send inquiries to P.O. Box 23225, Santa Fe, NM 87502, U.S.A., or visit the Center's Website (www.americanplaces.org).

## About the Book

The text for *Along the Divide: Photographs of the Dan Ryan Expressway* was set in ITC Franklin Gothic Book with ITC Franklin Gothic Demi display. The paper is acid-free Silk Gallery, 157 gsm weight. The four-color separations, printing, and binding were professionally rendered by Oddi Printing Ltd., of Reykjavik, Iceland. *Along the Divide* was published in association with the Photography Department at Columbia College Chicago, which is the nation's largest and one of the nation's most prestigious photography programs. For more information, visit online at: www.colum.edu/undergraduate/photo.

**For the Center for American Places**
George F. Thompson, President and Publisher
Randall B. Jones, Associate Editorial Director
Kendall B. McGhee, Publishing Liaison and Assistant Editor

**For Columbia College Chicago**
Sarah Faust, Book Designer
Mary Johnson, Director of Creative and Printing Services
Anita Strejc, Type Specialist
Christine DiThomas, Manuscript Editor
Benjamin Gest, Director of Digital Scans
Thomas Shirley, Coordinator of Digital Imaging
Bob Thall, Chairman, Photography Department